# Photoshop 7

# TYPE EFFECTS

# Photoshop 7 Type Effects

Credits: Senior Editor, Mark Garvey; Technical Editor, Lisa Bucki; Cover Design, Chad Planner; Interior Design and Layout, Marian Hartsough; Proofreader, Karen Annett.

Publisher: Andy Shafran.

Technology is constantly changing; due to the lapse of time between the writing and distribution of this book, some aspects might be out of date. Accordingly, the author and publisher assume no responsibility for actions taken by readers based upon the contents of this book.

Library of Congress Catalog Number: 2002115218

ISBN  1-932094-20-2

5  4  3  2  1

Educational facilities, companies, and organizations interested in multiple copies or licensing of this book should contact the publisher for quantity discount information. Training manuals, CD-ROMs, and portions of this book are also available individually or can be tailored for specific needs.

Muska & Lipman Publishing
2645  Erie Avenue, Suite 41
Cincinnati, Ohio 45208
www.muskalipman.com
publisher@muskalipman.com

# Photoshop 7 Type Effects

CD-ROM Organization

# The CD-ROM

The supplementary CD-ROM contains all of the source elements used to create the images found in this book.

# Source Data

All example sources and image files needed are contained on the CD-ROM. You will find them in the "sources" subdirectory.

# Projects

Finished projects can be found on the CD-ROM in the "projects" directory.

# Contents

Project 1
Neon Effect Type    2

Project 2
Irregular Cracks    10

Project 3
Punch Hole Array    20

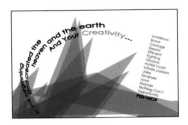

Project 4
Creative Wave    30

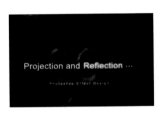

Project 5
A Grotesque Monster    40

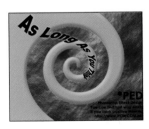

Project 6
Swirl Style    50

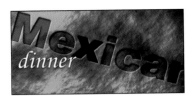

Project 7
Impressed Type    62

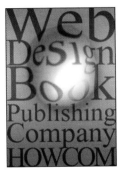

Project 8
Water Drop Type    74

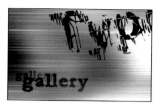

Project 9
Grunge Type    86

Project 12
Blur Effect Type    124

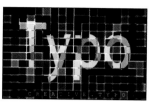

Project 15
Glass Block Refraction    166

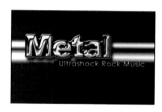

Project 10
Rounded Metal Type    98

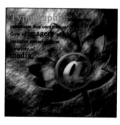

Project 13
Simple Glass Type    138

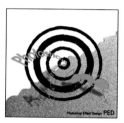

Project 16
An Ant Hole    180

Project 11
Caught in a Net    110

Project 14
Fire Shock    152

Project 17
Universal Light    196

# Contents

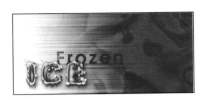

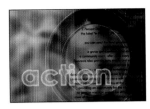

Project 18
**3-D Block Array** 210

Project 19
**Ice Type** 224

Project 20
**Action Type** 238

# Photoshop 7
# TYPE EFFECTS

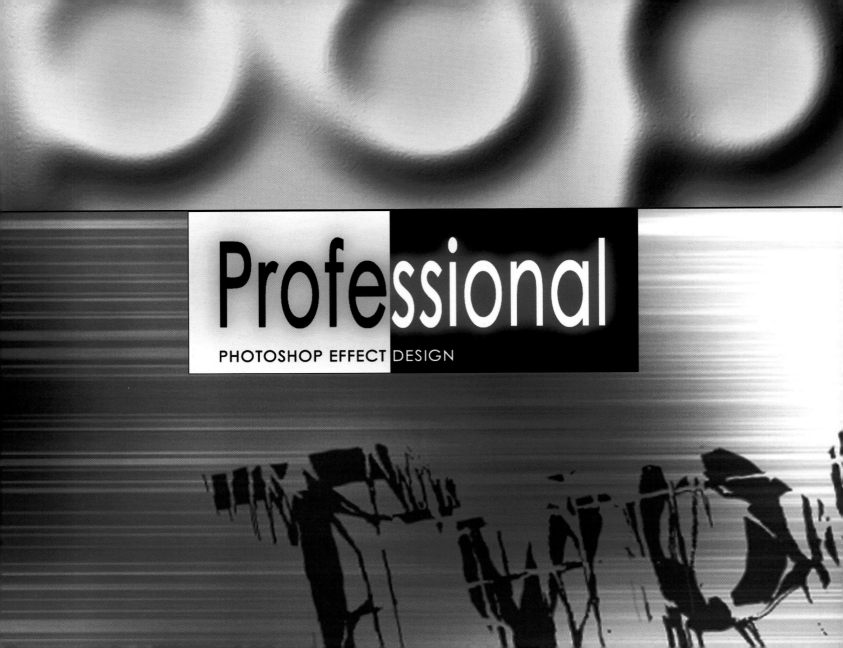

# Project 1: Neon Effect Type

Typography, an essential aspect of printing, is an immovable force in the field of graphic design. Rather than simply relaying a message, typography uses the shape of the letters and the space around the letters to amplify the artistic domain. In this book, you will learn how to use Photoshop to apply a variety of different effects to text. You will also learn how to use text effects in a variety of mediums, including Web images and posters.

Use layer styles, without the use of filters, to create neon type of the desired color.

Neon Effect Type

Project 1: Neon Effect Type

SSi DESIGN

## Total Steps

STEP 1. Creating a New File with a Black Background

STEP 2. Adding White Text

STEP 3. Scaling and Duplicating the Text

STEP 4. Applying a Glow Effect to the Original Text Layer

STEP 5. Applying a Glow Effect to the Copied Text Layer

STEP 6. Inverting a Portion of the Image

STEP 7. Typing in the Remaining Text

## STEP 1. Creating a New File with a Black Background

Choose File, New from the menu bar. To accommodate the size of the text you will add, set the Width and Height of the new file to 800 pixels and 300 pixels, respectively. Also set the Resolution to 100 pixels/inch, and then click OK to finish creating the new file. Set the foreground color to black and then use the Paint Bucket tool from the toolbox (or press Alt/Option+Del) to fill the file window with the selected color. Adjust the image zoom to a larger percentage, if desired.

## STEP 2. Adding White Text

Set the foreground color back to white, and choose the Horizontal Type tool from the toolbox. Click the Toggle the Character and Paragraph palettes button on the Options bar to open the Character palette. Use the Character palette to adjust the font, font size, and spacing as desired. Click in the file window to position the insertion point, and then type the text shown here. The new text layer appears above the background layer in the Layers palette. You can close the Character palette if desired.

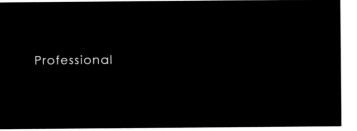

## STEP 3. Scaling and Duplicating the Text

With the new text layer selected in the Layers palette, choose Edit, Transform, Scale. Drag the selection handles that appear around the text to enlarge the letters so that they fill up the image window, and then press Enter/Return. In order to add the neon effect, you need to duplicate the text layer. To do so, make sure the text layer is selected in the Layers palette, and then choose Layer, New, Layer via Copy (Ctrl/Command+J) to copy the layer.

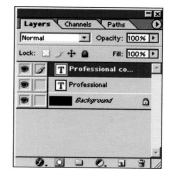

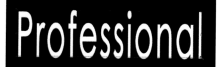

## STEP 4. Applying a Glow Effect to the Original Text Layer

Click the original text layer in the Layers palette, click the Add a layer style button at the bottom of the Layers palette, and then click Outer Glow. The Layer Style dialog box opens with the outer glow settings displayed. Outer glow, as the name suggests, creates a glow along the outside of the text. Choose the values shown here to create narrow light diffusions along the outside of the text, and click OK.

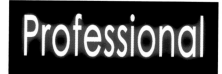

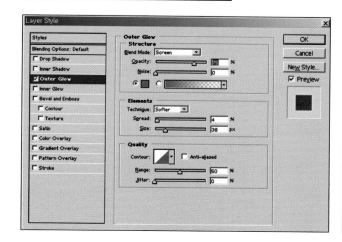

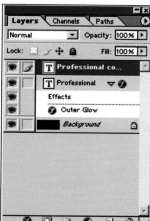

## STEP 5. Applying a Glow Effect to the Copied Text Layer

Click the text layer copy in the Layers palette, then click the Add a layer style button at the bottom of the Layers palette, and then click Outer Glow. The Layer Style dialog box opens again. Choose the values shown here to apply a second, wider light diffusion on the copied layer, and then click OK. When the two glow effects overlap, powerful light effects appear near the text, creating a wider diffusion to mimic neon effects.

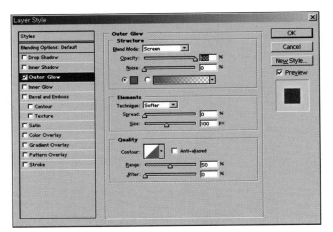

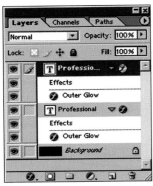

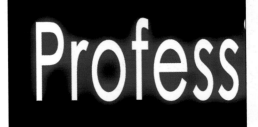

Step 1

Step 2

Step 3

Step 7

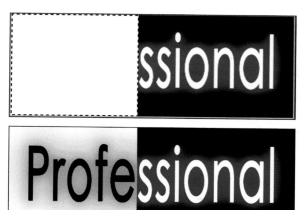

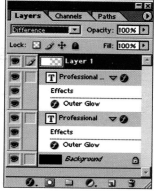

## STEP 6. Inverting a Portion of the Image

To apply inverted effects to some portions of the text, click the Create a new layer button (Shift+Ctrl/Command+N) in the Layers palette to make a new layer, and click OK in the New Layer dialog box if it appears. Use the Rectangular Marquee tool from the toolbox to select the area that will be inverted, as shown here.

Set the foreground color to white, and then use the Paint Bucket tool (Alt+Del) to fill the selection. Choose Select, Deselect (Ctrl/Command+D) from the menu bar to remove the selection marquee. With the new layer still selected in the Layers palette, click the Add a layer style button at the bottom of the Layers palette, and then click Blending Options. Choose Difference as the Blend Mode setting in the Layer Style dialog box, and then click OK to create the inverted effect seen here.

## STEP 7. Typing in the Remaining Text

Click the Create a new layer button (Shift+Ctrl/Command+N) in the Layers palette to make a new layer. (Click OK if the New Layer dialog box appears.) Set the foreground color to black, and then use the Horizontal Type tool from the toolbox to specify the font and font size shown here in the Character palette. Click just below the P in Professional, and then type the text shown at the bottom of the final illustration here. When the insertion point leaves the inverted portion of the image, the text color will change from black to white.

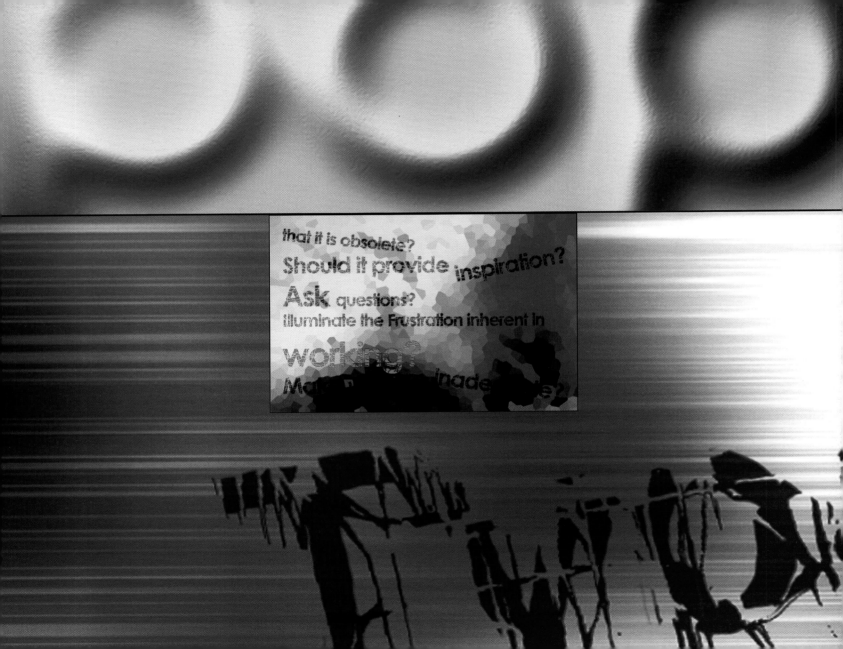

that it is obsolete?

Should it provide inspiration?

Ask questions?

illuminate the Frustration inherent in

working?

Ma                 inade          e?

# Project 2: Irregular Cracks

In this project, add irregular cracks to fixed letter shapes. Use the Define Pattern and Paint Bucket tools to apply irregular crystallization to the entire background.

Irregular Cracks

that it is obsolete?
Should it provide inspiration?
Ask questions?
Illuminate the Frustration inherent in
working?
Make you feel inadequate?

# Project 2: Irregular Cracks

## Total Steps

STEP 1.   Crystallizing the Background

STEP 2.   Sharpening the Background Color

STEP 3.   Entering Text

STEP 4.   Adjusting the Font Size and Color

STEP 5.   Making a Pattern from Irregular Lines

STEP 6.   Applying the Pattern to a Layer

STEP 7.   Deleting the Pattern from the Text

STEP 8.   Completing the Irregular Cracks

STEP 9.   Adjusting Text Size and Direction

STEP 10.  Making a Text Selection to a New Layer

STEP 11.  Positioning the Text

STEP 12.  Blending the Original Text's Colors

STEP 13.  Viewing the Result

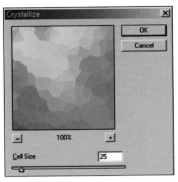

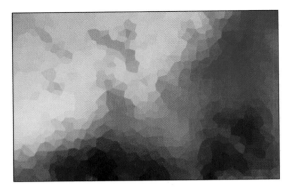

## STEP 1. Crystallizing the Background

Choose File, Open (Ctrl/Command+O) and open the Book\Sources\bg_source.jpg file from the supplementary CD-ROM.

To apply crystallization to this image, which serves as the Background layer for the project, choose Filter, Pixelate, Crystallize. In the Crystallize dialog box that appears, set the Cell Size to 25, and then click OK.

## STEP 2. Sharpening the Background Color

Next, sharpen the Background layer's color using the Curves dialog box. Choose Image, Adjustments, Curves (Ctrl/Command+M). In the Curves dialog box, bend the curve into an S-shape. To do so, click the diagonal line to create two points on the curve, and then drag them into position. Click OK to apply the changes to the image.

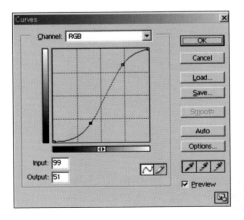

## STEP 3. Entering Text

Set the foreground color to black, and choose the Horizontal Type tool from the toolbox. Click the Toggle the Character and Paragraph palettes button on the Options bar to open the Character palette. Use the Character palette to adjust the font, font size, and spacing as desired. Click in the file window to position the insertion point, and then type the text. Click the Commit any current edits button at the right end of the Options bar to finish entering text. The new text layer appears above the Background layer in the Layers palette.

## STEP 4. Adjusting the Font Size and Color

Alter the font size for selected words and lines to break the tedium and to make the text easier to read.

Select each word or phrase, and then change settings on the Character palette as desired. Click the Commit any current edits button at the right end of the Options bar to finish the changes. Choose Select, Deselect (Ctrl/Command+D) to remove any selection. Click the Color box on the Character palette, choose a red in the Color Picker dialog box, and click OK. This changes all the text to the red color. You can close the Character palette if desired.

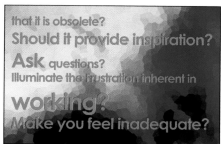

## STEP 5. Making a Pattern from Irregular Lines

To create the irregular weblike lines that will be used as the pattern for the cracks in the letters, click the Create a new layer button at the bottom of the Layers palette to make a new layer. Because this may interfere with the other images we have made up until this point, click on the eye icon beside each of the other two layers to hide them. Choose the Pencil tool from the toolbox. In the Options bar, use the Brush Preset picker to set the brush diameter to 1 px (1 pixel). After setting the foreground color to black, if needed, scribble in irregular lines in a portion of the image window. Use the Rectangular Marquee tool to select all or part of the area where you drew the lines.

Choose Edit, Define Pattern. Type a name for the pattern into the Name text box of the Pattern Name dialog box, and click OK to finish creating the pattern.

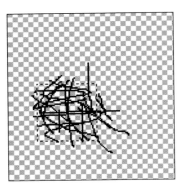

## STEP 6. Applying the Pattern to a Layer

Choose Select, Deselect (Ctrl/Command+D) from the menu bar to clear the selection on Layer 1. With Layer 1 still selected in the Layers palette, choose Edit, Fill to open the Fill dialog box. Choose Pattern from the Use drop-down list. Click the Custom Pattern selection icon, and click the custom pattern you created in the previous step. Click OK to apply the pattern to the entire layer.

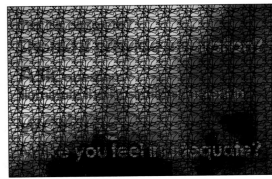

## STEP 7. Deleting the Pattern from the Text

Click the box for the eye icon beside the text layer to redisplay the text. Right/Control-click the text layer in the Layers palette, and click Rasterize Layer to convert the vector text layer to a bitmapped image layer. With the text layer still selected, Ctrl/Command-click the pattern layer (Layer 1) to select the pattern lines. Then, press the Del key to remove portions of the text that were covered by the lines. Choose Select, Deselect (Ctrl/Command+D) to remove the selection.

## STEP 8. Completing the Irregular Cracks

Now, click on the eye icon beside the pattern (Layer 1) layer in the Layers palette to hide the pattern layer. Click the box for the eye icon beside the Background layer to redisplay it. You now can see that the area of irregular pattern lines has been removed from the text to create cracked letters.

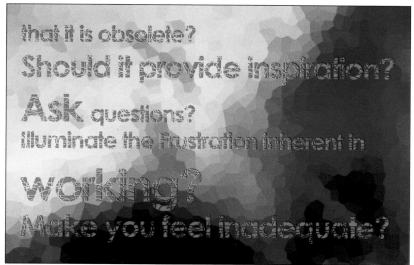

## STEP 9. Adjusting Text Size and Direction

Now, you change the location and size of selected words or phrases on the text layer. Click on the text layer in the Layers palette to select the layer. Choose the Rectangular Marquee tool from the toolbox. Select a word or phrase on the layer, and then choose Edit, Free Transform (Ctrl/Command+T). Use the handles that appear to rotate, reposition, or adjust the size of the selection. Press Enter/Return to apply your changes. Repeat as needed for other selections.

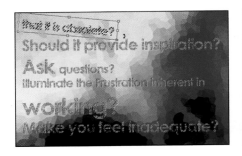

## STEP 10. Moving a Text Selection to a New Layer

Next, you need to adjust the blending options to make all the text, except the word "working," appear more natural. This requires first moving the word "working" to a new layer of its own. With the text layer still selected in the Layers palette, use the Rectangular Marquee tool to select the word "working." Choose Edit, Cut (Ctrl/Command+X) to remove the selection from the existing text layer. Choose Edit, Paste (Ctrl/Command+V) to paste the cut selection into a new layer, named Layer 2 by default.

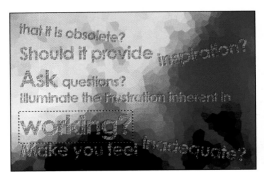

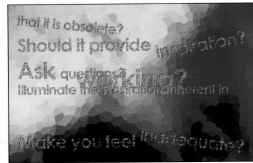

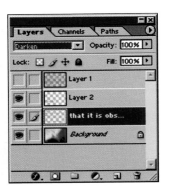

## STEP 11. Positioning the Text

Choose the Move tool from the toolbox, and use it to move the word "working" to its original position in the new layer, Layer 2.

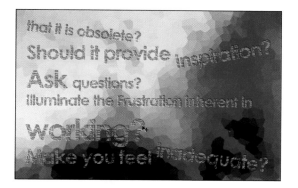

## STEP 12. Blending the Original Text's Colors

Click the original text layer in the Layers palette to select it. Click the Add a layer style button at the bottom of the Layers palette, and choose Blending Options. Choose Darken from the Blend Mode drop-down list, and click OK. This choice compares the colors on the Background layer and the selected layer, applying the darker color to each non-transparent pixel on the selected layer.

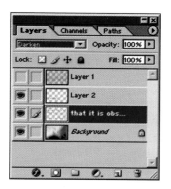

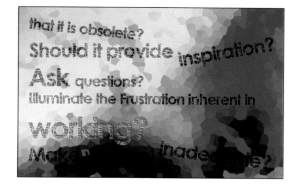

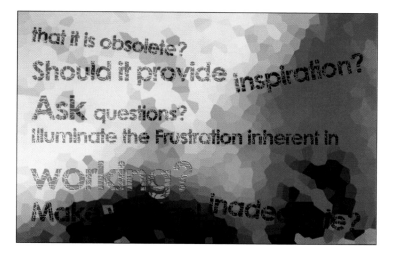

## STEP 13. Viewing the Result

You have arranged the text naturally. You have also added cracks to the text and have toned down all the text except the word "working." This makes the text look like a woodcut print made on old and crumpled paper.

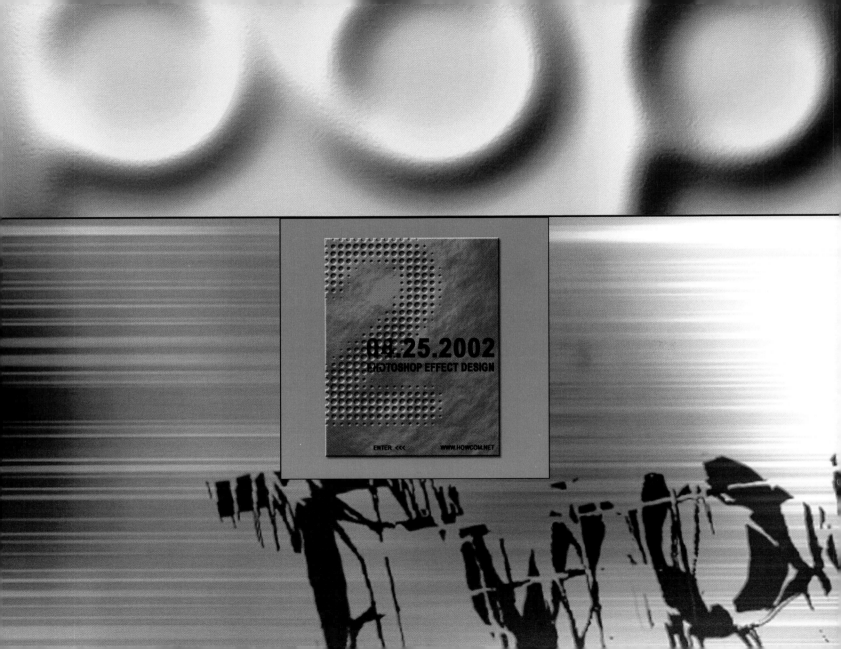

# Project 3: Punch Hole Array

In this project, you use a lattice of punched-out holes to create a large number. Learn how to use the Color Halftone filter to display the number as a lattice of colored dots. Build on the effect by adding a layer with the appearance of punched-out holes and using other filters and layer styles to create dimensionality.

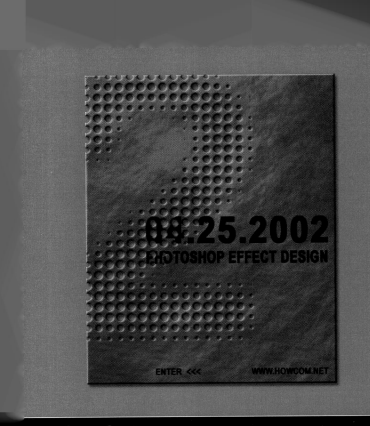

08.25.2002
PHOTOSHOP EFFECT DESIGN

ENTER <<<                WWW.HOWCOM.NET

Punch Hole Array

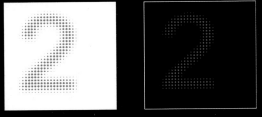

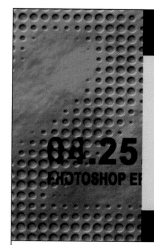

# Project 3: Punch Hole Array

## Total Steps

STEP 1.  Entering a 2 in a New Image Window

STEP 2.  Adjusting the Size and Color of the 2

STEP 3.  Blurring the 2

STEP 4.  Portraying the Text as Colored Dots

STEP 5.  Adding a Black Background

STEP 6.  Adding Red to the Black Background

STEP 7.  Making the Black Panel Gray

STEP 8.  Applying Dimensionality to the Gray Panel

STEP 9.  Adding a Cloud Texture Layer

STEP 10.  Adding Dimensional Lighting to the Cloud Texture

STEP 11.  Blending the Cloud Texture and the Text Panel

STEP 12.  Softening the Texture

STEP 13.  Adding Text to Complete the Image

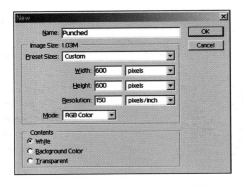

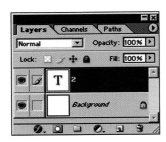

## STEP 1. Entering a 2 in a New Image Window

Choose File, New (Ctrl/Command+N) to create a new file. Set both the Width and Height of the new file to 600 pixels. Change the Resolution to 150 pixels/inch. Click OK. Choose the Horizontal Type tool from the toolbox, click in the image window, and enter the number "2." Click the Commit any current edits button at the right end of the Options bar to finish entering text.

## STEP 2. Adjusting the Size and Color of the 2

Click the new text layer in the Layers palette. With the Horizontal Type tool still selected, open the Character palette. Click the Color box to display the Color Picker dialog box. Choose a light red. To specify a precise color, click the R, G, and B option buttons in turn, and enter the following values for each—

R:255, G:160, B:160. Click OK to set the text color to light red. Close the Character palette if desired. Choose Edit, Free Transform (Ctrl/Command+T). Use the handles that appear to stretch the number to fill the screen, and press Enter/Return to finish the change.

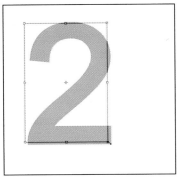

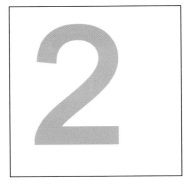

### STEP 3. Blurring the 2

Click the palette menu button at the top-right corner of the Layers palette, and click Merge Visible (Shift+Ctrl/Command+E) to combine the text and background layers. Then, choose Filter, Blur, Gaussian Blur. In

the Gaussian Blur dialog box, increase the Radius setting to approximately 12.6, and then click OK to soften the edges of the number as shown here.

### STEP 4. Portraying the Text as Colored Dots

Next, intensify the white tones in the image so that the outer edge of the number becomes completely white. Choose Image, Adjustments, Levels (Ctrl/Command+L) to open the Levels dialog box. Slowly drag the rightmost Input Levels slider to the left, until the right Input Levels value is approximately 245. Click OK to apply the change. Choose Filter, Pixelate, Color Halftone to open the Color Halftone dialog box. Set the Max. Radius to 12 and set all Channel values, except Channel 1, to 0. (Leave the Channel 1 setting as is.) Click OK. The red channel in the image displays a lattice of 12-pixel dots.

## STEP 5. Adding a Black Background

Choose the Magic Wand tool from the toolbar, and then click the white background in the image to select only the background. Click the Create a new layer button (Shift+Ctrl/Command+N) in the Layers palette to make a new layer named Layer 1 by default. After setting the foreground color to black, press Alt/Option+Del to quickly fill the selection in black on the new layer. Choose Select, Deselect (Ctrl/Command+D) to remove the selection.

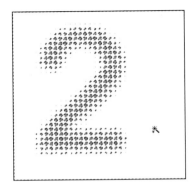

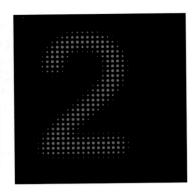

## STEP 6. Adding Red to the Black Background

Using the Rectangular Marquee tool, make the rectangular selection shown here on the Layer 1 layer. Choose Select, Inverse (Shift+Ctrl/Command+I) to invert the selection. Press the Del key to delete the outer area, which is now the selection frame. Choose Select, Deselect (Ctrl/Command+D) to remove the selection. After setting the foreground color to red using the toolbox or color palette, click the Background layer in the Layers palette and press Alt/Option+Del to make the selected area in the Background layer red.

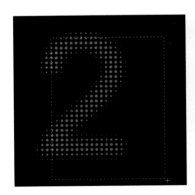

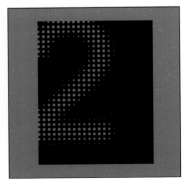

## STEP 7. Making the Black Panel Gray

Choose Select, Inverse (Shift+Ctrl/Command+I) to invert the selection, and then click on the Layer 1 layer in the Layers palette. Choose Image, Adjustments, Hue/Saturation (Ctrl/Command+U). Drag the Lightness slider to the right to increase the Lightness to approximately 50. Click OK to apply the change, which lightens the black panel in the image to a grayish tone.

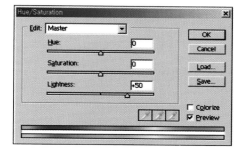

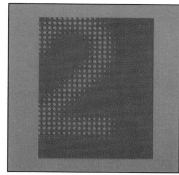

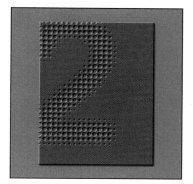

## STEP 8. Applying Dimensionality to the Gray Panel

Click the Add a layer style button on the Layers palette, click Drop Shadow, and click OK in the Layer Style dialog box. Click the Add a layer style button on the Layers palette, click Bevel and Emboss, and click OK in the Layer Style dialog box. These two layer styles add a shadow and embossing to the gray panel. Icons for the layer styles appear below the selected layer in the Layers palette. If you want to adjust either value, double-click the layer style in the Layers palette to open the Layer Style dialog box, make the desired changes, and click OK.

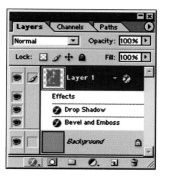

## STEP 9. Adding a Cloud Texture Layer

With the gray panel area still selected, click the Create a new layer button (Shift+Ctrl/Command+N) on the Layers palette to make a new layer. After setting the foreground color to black and the background color to white, choose Filter, Render, Clouds. A cloud image will appear in the new layer. Because the Clouds filter command changes the shape of the clouds randomly, it is nearly impossible to achieve the same results shown here. Reapply the Clouds filter by pressing Ctrl/Command+F until you obtain the desired results.

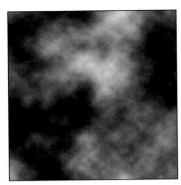

## STEP 10. Adding Dimensional Lighting to the Cloud Texture

Choose Filter, Render, Lighting Effects to open the Lighting Effects dialog box. Set the Texture Channel to Red. Drag the Height slider to the right to increase the Height setting to approximately 67, and then click OK. The filter settings adjust the cloud texture to create a jagged, rocklike appearance.

## STEP 11. Blending the Cloud Texture and the Gray Panel

Look at the Layers palette. Layer 2, with the now jagged, rocklike texture appears above the Layer 1 layer, which holds the gray panel. Press and hold the Alt/Option key, and then click the border between the two layers to group them together. The transparent regions of the gray panel layer are applied to the texture layer, so the holes in the grid show through the texture.

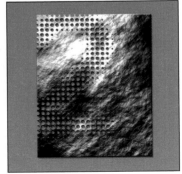

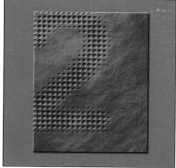

## STEP 12. Softening the Texture

The rocklike texture overpowers the image, so you can soften the texture next. With Layer 2 (the texture layer) selected, click the Add a layer style button at the bottom of the Layers palette. In the Layer Style dialog box, choose Soft Light from the Blend Mode drop-down list. Drag the Opacity slider to reduce the Opacity setting to 45%. Click OK. The softened texture combined with the gray panel takes on a metallic appearance.

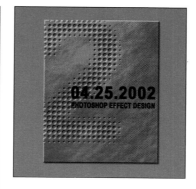
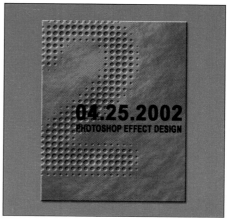

## STEP 13. Adding Text to Complete the Image

Choose the Horizontal Type tool from the toolbox. Display the Character palette, choose the desired font and large size, choose black as the color, and type 04.25.2002 to create the first text layer. Click the Commit any current edits button on the Options bar to finish adding the layer. Repeat the process to add the text shown here on additional layers. To have the red dots or holes show through the black lettering, Alt/Option-click on the border between the first text layer and Layer 2 (the texture layer) to group them together. (Alt/Option-click the border between additional text layers higher in the Layers palette to group them with the layers below, as well.) The shadow and bevel layer effects applied to Layer 1 (the texture layer) are applied to all the grouped layers, as well.

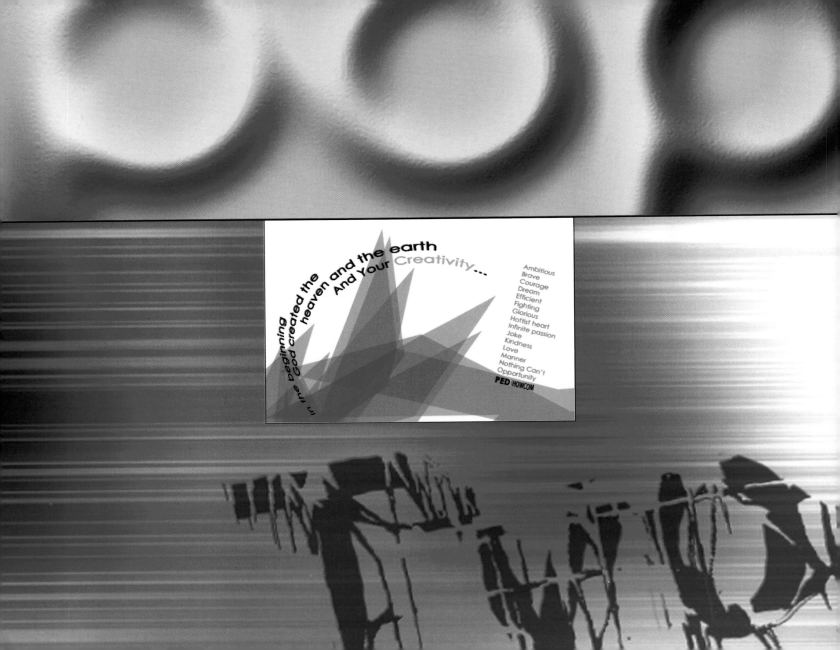

# Project 4: Creative Wave

The Polar Coordinates filter enables you to curve text in an image. In this project, you will use the Polar Coordinates filter to create a wave effect with several lines of text.

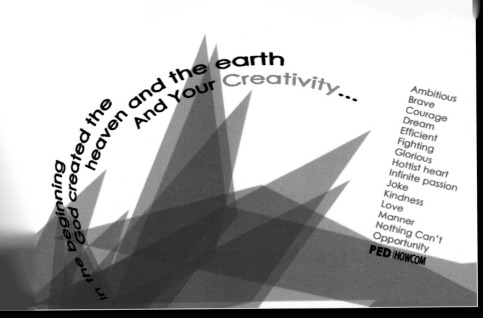

Creative Wave

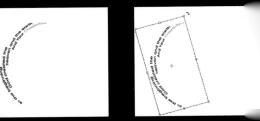

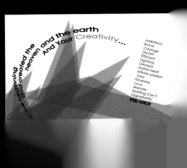

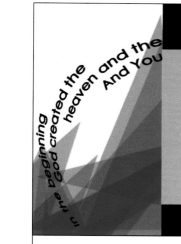

# Project 4: Creative Wave

## Total Steps

STEP 1.   Entering Text in a Stair Shape

STEP 2.   Flipping the Text and Moving It to the Bottom of the Image

STEP 3.   Merging the Text with the Background Layer

STEP 4.   Rolling the Text

STEP 5.   Rotating the Text

STEP 6.   Reshaping the Text and Rotating It Again

STEP 7.   Sharpening the Text

STEP 8.   Reducing the Image to Actual Size

STEP 9.   Making a Sharp Shape

STEP 10.   Overlapping and Arranging Shapes

STEP 11.   Cropping the Image

STEP 12.   Adding More Text

STEP 13.   Rotating and Arranging the Text

## STEP 1. Entering Text in a Stair Shape

Choose File, New (Ctrl/Command+N) to create a new file. In the New dialog box, set both the Width and Height of the new file to 1600 pixels. Click OK. Eventually, you will reduce the image to half this size. Use the Horizontal Type tool from the toolbox to enter in the text in the stair-stepped manner shown here. Be sure to use the Character palette to reduce the Horizontally scale setting to 50%. Format the final word, "Creativity," in red. Click the Commit any current edits button at the right end of the Options bar to finish entering the text.

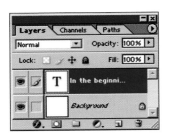

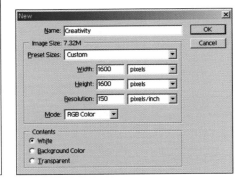

## STEP 2. Flipping the Text and Moving It to the Bottom of the Image

Choose Edit, Transform, Rotate 180° to flip the text over. Then, choose Edit, Free Transform (Ctrl/Command+T), and drag one of the corner handles that appears to reduce the size of the text object. Press Enter/Return to finish resizing the text. Finally, click the Move tool on the toolbox and drag the text to the lower-left corner of the image.

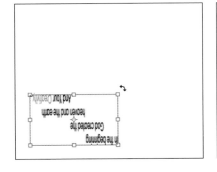

## STEP 3. Merging the Text with the Background Layer

With the text layer selected in the Layers palette, choose Layer, New, Layer via Copy (Ctrl/Command+J) to duplicate the layer. Click on the eye icon beside the new layer to hide it. Click the original text layer to select it. Click the palette menu button at the top of the Layers palette, and click Merge Down (Ctrl/Command+E) to merge the original text layer with the Background layer.

## STEP 4. Rolling the Text

Choose Select, All (Ctrl/Command+A) to select the contents of the Background layer. Choose Filter, Distort, Polar Coordinates. Click the minus (-) button in the Polar Coordinates dialog box until you can see the preview of the text rounded into a semicircle. Click OK to close the dialog box and apply the new shape.

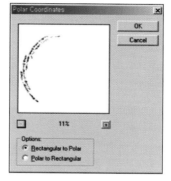

## STEP 5. Rotating the Text

Choose the Rectangular Marquee tool from the toolbox, and then drag a corner of the selection marquee to adjust its size as shown here. Choose Edit, Transform, Rotate. Drag the upper-right selection handle to the left to rotate the text a bit. Press Enter/Return to apply the change. Choose Select, Deselect (Ctrl/Command+D) to remove the current selection.

 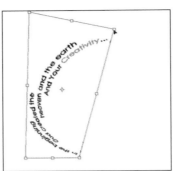 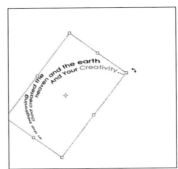 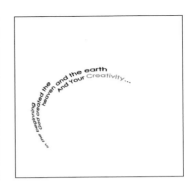

## STEP 6. Reshaping the Text and Rotating It Again

Use the Rectangular Marquee tool to select the text, and then choose Edit, Transform, Distort. Drag the four selection handles to distort the text to the shape shown here. Press Enter/Return. Then, choose the Edit, Transform, Rotate command. Drag the upper-right selection handle down to rotate the text as shown here, and then press Enter/Return. (Drag the text from the center to reposition it on the image, if needed, before pressing Enter/Return.)

## STEP 7. Sharpening the Text

Choose Image, Adjustments, Levels (Ctrl/Command+L) from the menu bar. In the Levels dialog box, drag the leftmost Input Levels slider to the right to increase the first Input Levels setting to 100, and then click OK.

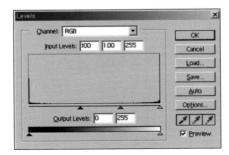

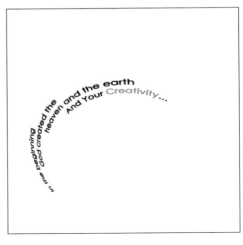

## STEP 8. Reducing the Image to Actual Size

The Polar Coordinates filter severely distorts the image such that the text can appear blurred. Reducing the image size after applying the Polar Coordinates filter helps sharpen the image. Choose Image, Image Size. Enter new Height and Width dimensions of 800 pixels, and then click OK. Zoom in on the image window, if needed.

## STEP 9. Making a Sharp Shape

Use the Polygonal Lasso tool from the toolbox to create the freeform selection shown here. Click on the Create a new layer button (Shift+Ctrl/Command+N) in the Layers palette to create a new layer named Layer 1 by default. Set the foreground color to sky blue. Select the Paint Bucket tool from the toolbox and click within the selection marquee (Alt/Option+Del) to fill the selection with the sky blue color. With Layer 1 (the shape layer) selected, click the Add a layer style button at the bottom of the Layers palette, and then click Blending Options. Choose Linear Burn from the Blend Mode drop-down list, and then click OK.

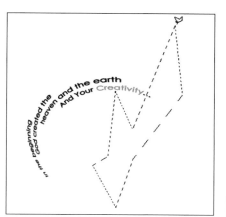
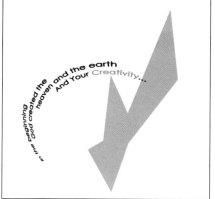

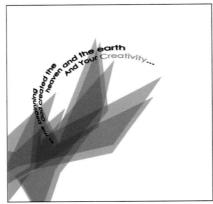
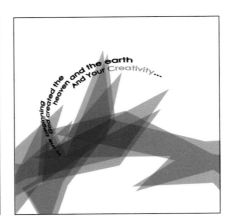

## STEP 10. Overlapping and Arranging Shapes

With Layer 1 selected in the Layers palette, choose Layer, New, Layer via Copy (Ctrl/Command+J). Use the Edit, Free Transform command (Ctrl/Command+T) to slightly alter the placement, size, and angle of the copied shape, allowing it to overlap the original shape. Press Enter/Return to finish adjusting the shape. Make several copies of Layer 1 and reposition the copies until you achieve the desired overlapping effect. Apply the Edit, Transform, Flip Horizontal command to a few of the copied shape layers to create a more diverse effect.

## STEP 11. Cropping the Image

Use the Rectangular Marquee tool to select the most interesting part of the image. Choose Image, Crop from the menu bar to discard the image area outside the selection. Choose Select, Deselect (Ctrl/Command+D) to remove the selection.

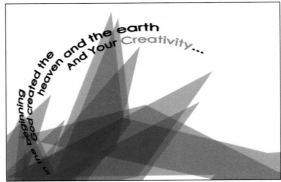

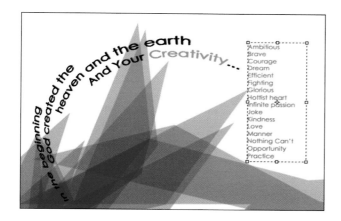

## STEP 12. Adding More Text

Choose the Horizontal Type tool from the toolbox. Drag over an area at the right side of the image to define an area to hold text. Open the Character palette and choose the desired font size. Also specify a gray color (R:131, G:131, B:131) for the text. Then, type in the text as shown here. Click the Commit any current edits button on the Options bar to finish entering the text.

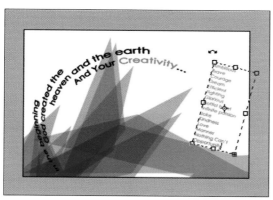

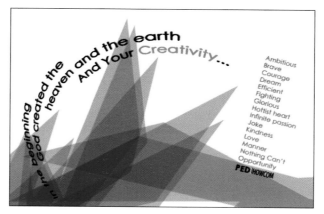

## STEP 13. Rotating and Arranging the Text

With the new text layer selected, choose Edit, Transform, Rotate. Drag a selection handle to rotate the text as desired. Drag from the center of the text to reposition the text as desired. Press Enter/Return to finish adjusting the text.

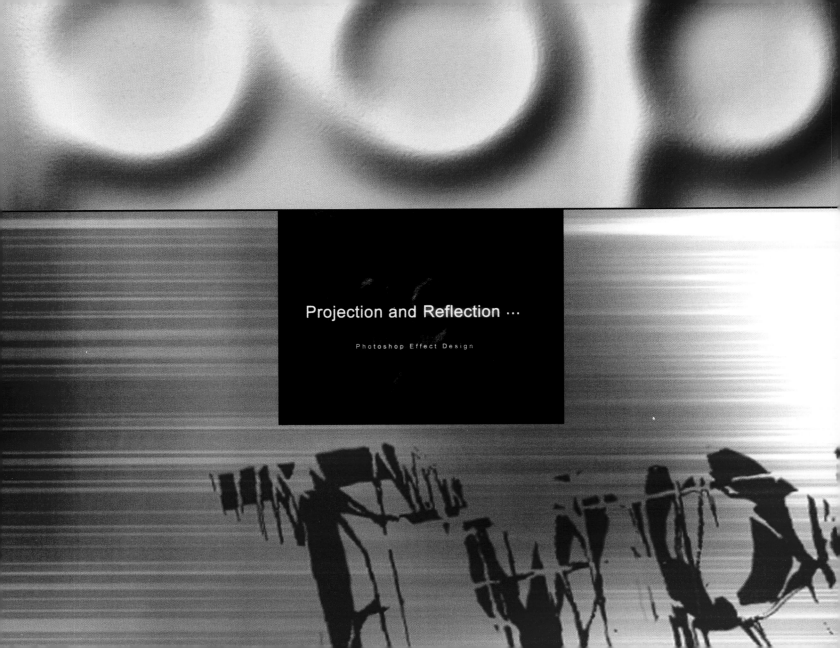

# Project 5: A Grotesque Monster

In this project, you will create 3-D text that appears to have been carved out of stone. You will add lighter areas to parts of the dark image to create the appearance of a gorilla's nose—an effect that's fun and scary all at the same time.

A Grotesque Monster

Projection and Reflection ···

Photoshop Effect Design

Projection and

Projection and Reflection ···

Projection and Reflection ···
Reflection

Projection and Reflection ···

Projection and Reflection ···
Photoshop Effect Design

# Project 5: A Grotesque Monster

Reflection

ffect Design

## Total Steps

STEP 1.    Making a New Image

STEP 2.    Entering Text

STEP 3.    Rasterizing the Text Layer

STEP 4.    Blurring the Text

STEP 5.    Blending the Text and Background Layers

STEP 6.    Adding a Cloud Effect

STEP 7    Darkening the Image

STEP 8.    Applying Dimensional Lighting to the Image

STEP 9.    Entering Text

STEP 10.   Entering the Remaining Text and Applying a Glow

STEP 11.   Making an Image Layer in the Shape of the Text

STEP 12.   Applying Motion Blur to the New Text

STEP 13.   Adding Text to Complete the Image

## STEP 1. Making a New Image

Choose File, New (Ctrl/Command+N). In the New dialog box, set the Width to 800 pixels and the Height to 600 pixels. Also set the Resolution to 100 pixels/inch, and then click OK.

## STEP 2. Entering Text

Choose the Horizontal Type tool from the toolbox. Open the Character palette by clicking the Toggle the Character and Paragraph palettes button on the Options bar, if needed. Specify the font and font size in the Character palette, and then click in the image window and type the

text shown here. Click the Commit any current edits button on the Options bar to finish. Choose Edit, Free Transform (Ctrl/Command+T) to drag a handle to further increase the size of the text, and press Enter/Return.

## STEP 3. Rasterizing the Text Layer

In the Layers palette, right/Control-click on the text layer, and then click Rasterize Layer in the shortcut menu. This converts the vector text layer into a bitmapped image layer.

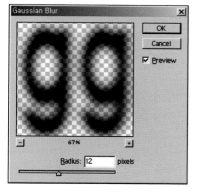

## STEP 4. Blurring the Text

With the text layer still selected in the Layers palette, choose Filter, Blur, Gaussian Blur. Click OK to apply the blur to the text.

## STEP 5. Merging the Text with the Background Layer

Click on the empty box beside the Background layer so that a chain link appears. This links the Background layer to the text layer. Click on the palette menu button in the top-right corner of the Layers palette, and click Merge Linked (Ctrl/Command+E) to merge the text into the Background layer.

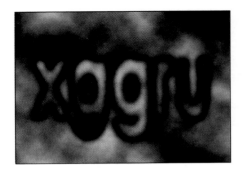

## STEP 6. Adding a Cloud Effect

Choose Filter, Render, Difference Clouds from the menu bar. You can reapply this filter to achieve a different effect. Alternate between pressing Ctrl/Command+F to apply the filter effect and pressing Ctrl/Command+Z to remove the filter effect until you achieve the desired result.

## STEP 7. Darkening the Image

To darken the image overall, choose Image, Adjustments, Levels (Ctrl/Command+L). In the Levels dialog box, drag the center Input Levels slider to the right to change the center Input Levels value to approximately .35. Click OK.

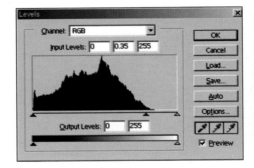

## STEP 8. Applying Dimensional Lighting to the Image

Choose Filter, Render, Lighting Effects from the menu bar. Choose Red from the Texture Channel drop-down list, and then click OK. This adjustment using the red channel gives more texture to the image. The shape of a gorilla's nose subtly emerges.

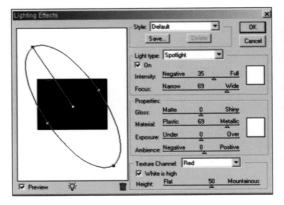

## STEP 9. Entering Text

Enter the white text shown here using the Horizontal Type tool, using the Character palette to specify the appropriate font, font size, and color. Click the Commit any current edits button on the Options bar to finish creating the text.

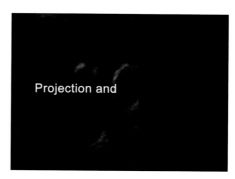

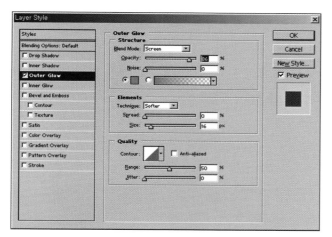

## STEP 10. Entering the Remaining Text and Applying a Glow

With the Horizontal Type tool still selected, add the last word, "Reflection." Click the Commit any current edits button to finish adding the text, which will appear on a layer separate from the text you added in Step 9. Use the Move tool from the toolbox to position the newly-added text. Click the Add a layer style button at the bottom of the Layers palette, and then click Outer Glow. Choose a red color in the Structure area, and increase the Size setting in the Elements area to 16. Click OK.

## STEP 11. Making an Image Layer in the Shape of the Text

Ctrl/Command-click the Reflection layer thumbnail in the Layers palette to select the letters. Choose the Rectangular Marquee tool from the toolbox, and use it to drag the selection marquee to the center of the image. (Move the mouse pointer over the center of the letters until you see an arrow pointer with a marquee, then drag to move the selection.) Click the Create a new layer button (Shift+Ctrl/Command+N) at the bottom of the Layers palette. After setting the foreground color to white, use the Paint Bucket tool to click within the selection marquee to make all the letters white.

| Step 10 | Step 11_1 | Step 11_2 | Step 12 | Step 13 |

## STEP 12. Applying Motion Blur to the New Text

Choose Select, Deselect (Ctrl/Command+D). With the latest text layer (Layer 1) still selected in the Layers palette, choose Filter, Blur, Gaussian Blur. Set the Radius to approximately 3.6 in the Gaussian Blur dialog box,

  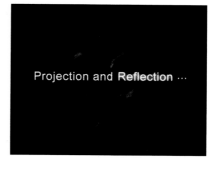

and then click OK. Choose Filter, Blur, Motion Blur. Set the Angle to -90 and the Distance to 65 pixels in the Motion Blur dialog box, and then click OK.

## STEP 13. Adding Text to Complete the Image

Choose the Horizontal Type tool from the toolbox. In the Character palette, specify the font, font size, and spacing settings shown here. Type the remaining text as shown. Click on the Commit any current edits button on the Options bar to finish, and close the Character palette.

  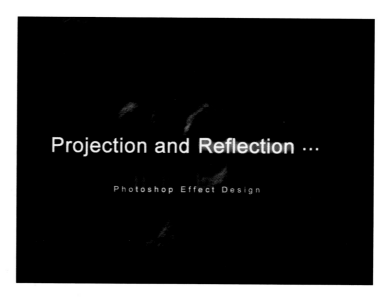

As Long As You Think

*PED
Photoshop Effect Design
You can find fast way easily
If you think positive thinking
http://www.HOWCOM.net

# Project 6: Swirl Style

In this project, use the Twirl filter to create a swirling image
and text. Fun styles and bright colors will draw viewers into
the vortex of the swirl.

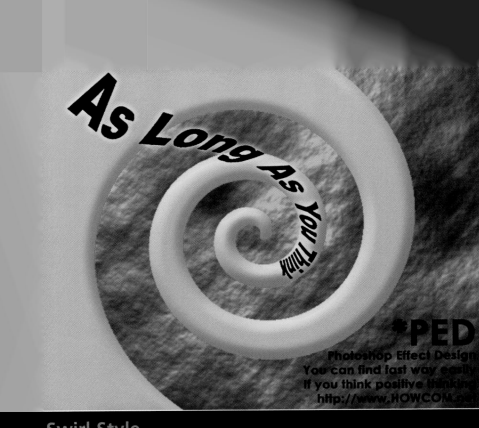

As Long As You Think

**\*PED**
Photoshop Effect Design
You can find fast way easily
If you think positive thinking
http://www.HOWCOM.net

Swirl Style

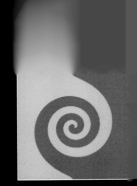
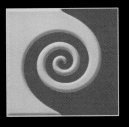

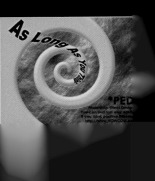

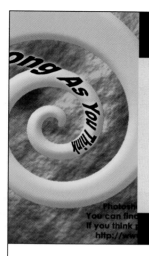

# Project 6: Swirl Style

## Total Steps

STEP 1.    Making a New Image with a Green Background

STEP 2.    Making Half the Image Yellow

STEP 3.    Making Swirl Effects

STEP 4.    Beveling the Swirl

STEP 5.    Adding the Title Shape

STEP 6.    Rotating the Title

STEP 7.    Twirling the Text

STEP 8.    Rotating the Twirled Text

STEP 9.    Adding a Glow to the Text

STEP 10.   Adding a Cloud Texture

STEP 11.   Blending the Cloud Texture

STEP 12.   Adding Final Text

STEP 13.   Removing an Unwanted Effect

STEP 14.   Cropping the Image

## STEP 1. Making a New Image with a Green Background

Choose File, New (Ctrl/Command+N) from the menu bar to open the New dialog box. Set both the Width and Height to 600 pixels and the Resolution to 150 pixels/inch. Click OK. After setting the foreground color to green (R:101, G:146, B:0), choose the Paint Bucket tool from the toolbox and click in the image or press Alt/Option+Del. This fills the Background layer with the green foreground color.

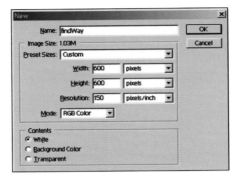

## STEP 2. Making Half the Image Yellow

Click the Create a new layer button (Shift+Ctrl/Command+N) at the bottom of the Layers palette to make a new layer. Use the Rectangular Marquee tool to select the left half of the image. Set the foreground color to yellow (R:255, G:192, B:0), and then use the Paint Bucket tool (Alt/Option+Del) to fill the selection. Choose Select, Deselect (Ctrl/Command+D) to remove the selection marquee.

## STEP 3. Making Swirl Effects

With Layer 1 still selected in the Layers palette,
choose Filter, Distort, Twirl from the menu bar. In
the Twirl dialog box, drag the Angle slider all the
way to the right to apply a large value. Click OK
to apply the twirl to Layer 1.

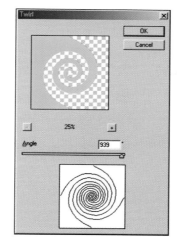
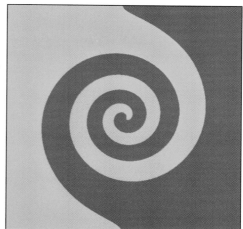

## STEP 4. Beveling the Swirl

With Layer 1 (the swirl layer) still selected in
the Layers palette, click the Add a layer style
button at the bottom of the palette. Click
Bevel and Emboss in the menu that appears.
Set the Bevel and Emboss values shown here in
the Layer Style dialog box, and then click OK
to add dimension to the swirl layer.

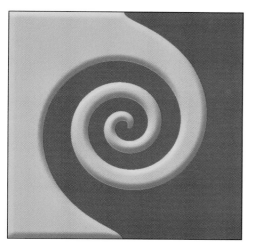
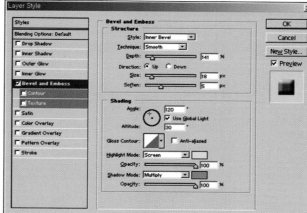

## STEP 5. Adding the Title Shape

Choose the Horizontal Type tool from the toolbox, and then display the Character palette by clicking the Toggle the Character and Paragraph palettes button. Choose the font settings shown here, type the text on the image, and then click the Commit any current edits button on the Options bar to finish the entry. Right/Control-click on the text in the image window, and choose Convert to Shape. (If you see an error message that the text uses a faux bold style, click OK. Then, right/Control-click the text and choose Faux Bold to remove the style.)

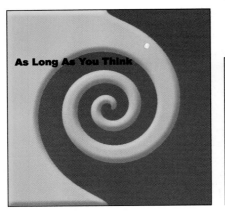

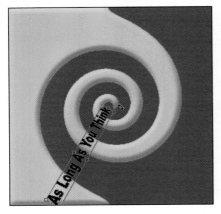

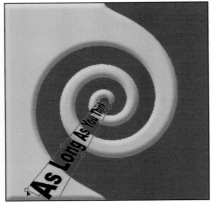

## STEP 6. Rotating the Title

Choose Edit, Free Transform (Ctrl/Command+T) from the menu bar. Move the mouse pointer outside a corner handle until you see a bent double-arrow pointer, and then drag to rotate the beginning of the text down to the left. Drag a corner selection handle to increase the text size. Press and hold the Ctrl/Command key, and drag one of the right-hand corners to skew the text. The text should slant from the center of the swirl down to the lower-left corner, and it should be smaller near the center of the swirl. Press Enter/Return to apply the transformation.

## STEP 7. Twirling the Text

Choose Filter, Distort, Twirl from the menu bar. Click OK when Photoshop prompts you to rasterize the shape layer. Drag the Angle slider to set the Angle to approximately 146°, and then click OK.

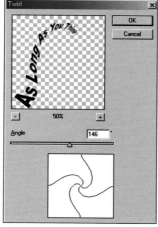

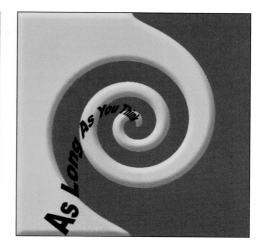

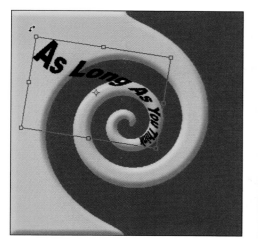

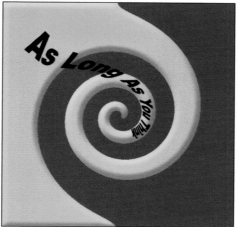

## STEP 8. Rotating the Twirled Text

Choose Edit, Free Transform (Ctrl/Command+T) from the menu bar. Rotate and move the text object so that the title appears as if it is being sucked into the vortex. Press Enter/Return to finish the transformation.

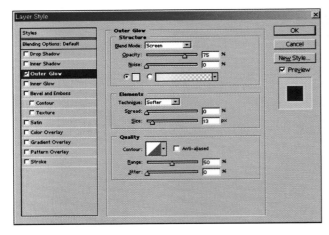

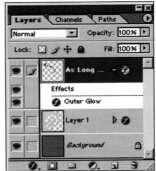

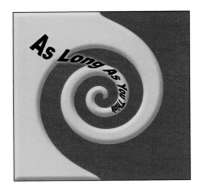

## STEP 9. Adding a Glow to the Text

With the text layer selected in the Layers palette, click the Add a layer style button at the bottom of the palette, and then click Outer Glow. Set the Outer Glow values in the Layer Style dialog box as shown here, and then click OK.

## STEP 10. Adding a Cloud Texture

Click the Create a new layer button (Shift+Ctrl/Command+N) in the Layers palette to add a new layer. Click the Default Foreground and Background Colors button on the toolbox to set the foreground color to black and the background color to white. Choose Filter, Render, Clouds from the menu bar to apply a cloud effect to the entire new layer, named Layer 2 by default. Continue to press Ctrl/Command+F to reapply the filter effect until the layer has the desired appearance.

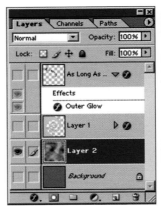

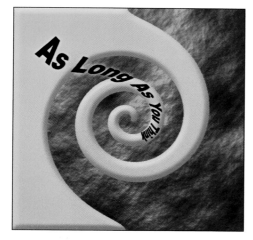

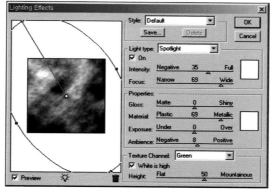

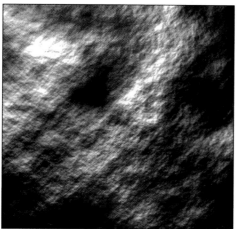

## STEP 11. Blending the Cloud Texture

With Layer 2 still selected in the Layers palette, choose Filter, Render, Lighting Effects to open the Lighting Effects dialog box. Adjust the light shape and direction in the Preview area as shown here, and then choose Green from the Texture Channel drop-down list. This will create a rocklike texture. Click OK. Click the Add a layer style button at the bottom of the Layers palette, and choose Blending Options. In the Layer Style dialog box, choose Linear Light from the Blend Mode drop-down list, change the Fill Opacity value to 30%, and click OK.

## STEP 12. Adding Final Text

Choose the Horizontal Type tool from the toolbox. Use the Character palette to choose the font settings shown here, and click the Right align text button on the Options bar. Add the text shown here, and then click the Commit any current edits button on the Options bar to finish.

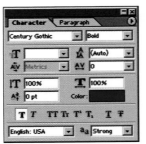
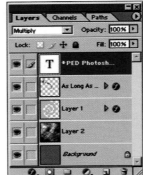
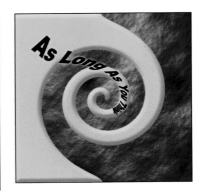

## STEP 13. Removing an Unwanted Effect

The Bevel and Emboss effect applied earlier to the Layer 1 (swirl) layer created unappealing shadows on the edges of the image. You can fix this now by merging layers. Click the Layer 1 (the swirl layer) thumbnail in the Layers palette, and then click the Create a new layer button (Shift+Ctrl/Command+N) to make a new layer above Layer 1 in the Layers palette. Click Layer 1 to reselect it, and then click the empty box beside Layer 3 so that a chain link appears to indicate that you've linked the two layers. Choose Layer, Merge Linked (Ctrl/Command+E) to merge the linked layers.

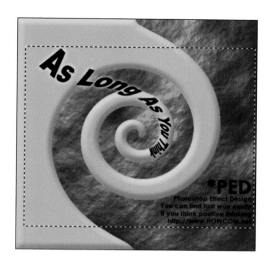

## STEP 14. Cropping the Image

Use the Rectangular Marquee tool to select the desired portion of the entire image. Choose Image, Crop from the menu bar to crop out the unwanted content.

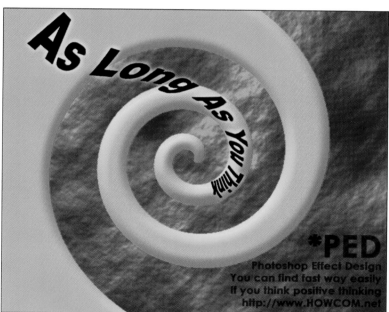

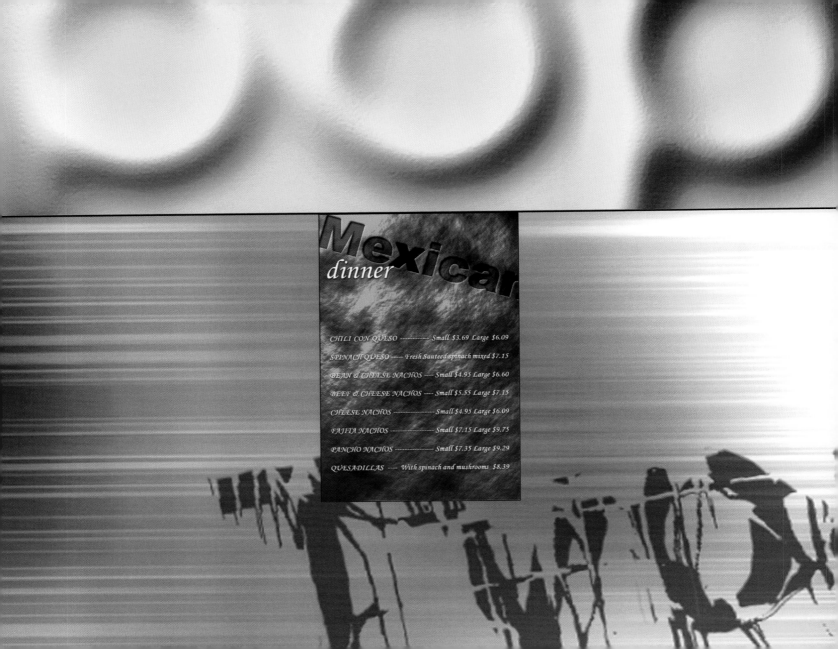

# Mexican
## dinner

CHILI CON QUESO ------------ Small $3.69 Large $6.09

SPINACH QUESO ----- Fresh Sauteed spinach mixed $7.15

BEAN & CHEESE NACHOS ---- Small $4.95 Large $6.60

BEEF & CHEESE NACHOS ---- Small $5.55 Large $7.15

CHEESE NACHOS ---------------- Small $4.95 Large $6.09

FAJITA NACHOS ----------------- Small $7.15 Large $9.75

PANCHO NACHOS ---------------- Small $7.35 Large $9.29

QUESADILLAS ---- With spinach and mushrooms $8.39

# Project 7: Impressed Type

This project introduces an impressed type effect that makes text appear to have been seared into the background. Learn how to create this marvelous type effect by moving and filling a selection.

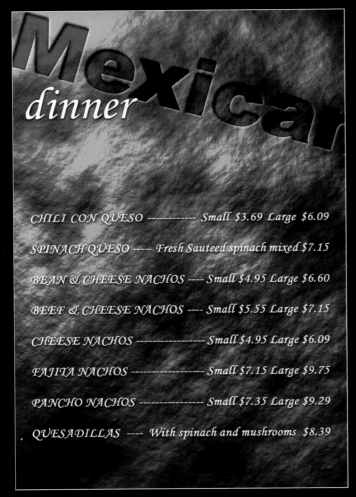

### dinner

CHILI CON QUESO ------------ Small $3.69 Large $6.09

SPINACH QUESO ---- Fresh Sauteed spinach mixed $7.15

BEAN & CHEESE NACHOS ---- Small $4.95 Large $6.60

BEEF & CHEESE NACHOS ---- Small $5.55 Large $7.15

CHEESE NACHOS --------------- Small $4.95 Large $6.09

FAJITA NACHOS ---------------- Small $7.15 Large $9.75

PANCHO NACHOS -------------- Small $7.35 Large $9.29

QUESADILLAS ---- With spinach and mushrooms $8.39

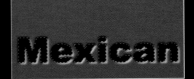
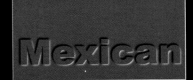
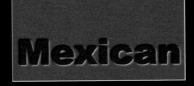
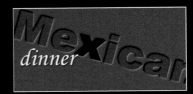

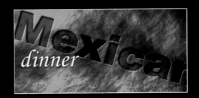

Impressed Type

64

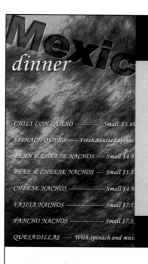

# Project 7: Impressed Type

## Total Steps

<div>

STEP 1. Making a New Image

STEP 2. Filling the Background

STEP 3. Entering Text

STEP 4. Specifying a Selection in the Shape of the Text

STEP 5. Moving and Filling the Selection

STEP 6. Creating the Impression Effect on the Text

STEP 7. Adding Inner Shadows to the Text

STEP 8. Increasing the Image Size

STEP 9. Rotating the Text

STEP 10. Changing a Letter's Color

STEP 11. Entering the Rest of the Text

STEP 12. Adding a Cloud Texture

STEP 13. Applying Directional Lighting to the Cloud Texture

STEP 14. Blending the Cloud Texture

STEP 15. Completing the Image

</div>

## STEP 1. Making a New Image

Choose File, New (Ctrl/Command+N) from the menu bar to open the New dialog box. Set the image Width to 800 pixels and the Height to 400 pixels. Set the Resolution to 200 pixels/inch. Click OK to finish creating the new image.

## STEP 2. Filling the Background

After setting the foreground color to brown, choose the Paint Bucket tool from the toolbox. Click on the Background layer or press Alt/Option+Del to fill it with the brown color.

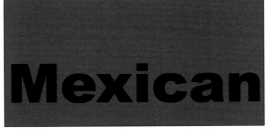

## STEP 3. Entering Text

Choose the Horizontal Type tool from the toolbox, and then display the Character palette, if needed, by clicking the Toggle the Character and Paragraph palettes button on the Options bar. Use the Character palette to choose the font and font settings shown here. Click in the image, type the word "Mexican" as shown here, and click the Commit any current edits button on the Options bar to finish your entries.

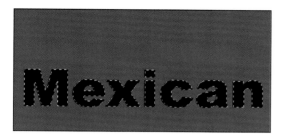   

### STEP 4. Specifying a Selection in the Shape of the Text

Click the thumbnail for the Background layer in the Layers palette, and then click the Create a new layer button (Shift+Ctrl/Command+N) to add a new layer (called Layer 1) above the Background layer. Ctrl/Command-click on the topmost text layer in the Layers palette to create a selection marquee in the shape of the letters. Click the eye icon beside the text layer to hide it, and then choose Select, Feather from the menu bar. Set the Feather Radius to 4 pixels in the Feather Selection dialog box, and then click OK to blur the edges of the new selection. If needed, click the Default Foreground and Background Colors button in the toolbox to reset the foreground color to black and the background color to white.

### STEP 5. Moving and Filling the Selection

Click Layer 1 in the Layers palette to select the layer, if needed. Then use the arrow keys on the keyboard to move the selection marquee. Press the → and ↓ keys twice 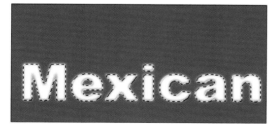 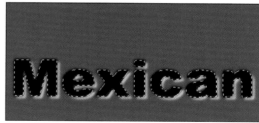 each to move the marquee slightly down and to the right. Choose the Paint Bucket tool from the toolbox, press Ctrl/Command+Del to fill the selection with the background color, white. Then, press the ← and ↑ keys four times each to move the selection marquee slightly up and to the left. Press Alt/Option+Del to fill the selection with the foreground color (black).

## STEP 6. Creating the Impression Effect on the Text

In the Layers palette, Ctrl/Command-click on the text layer to again create a selection marquee in the shape of the letters. With the Layer 1 layer selected, press the Del key to remove the colored pixels in the selection, allowing the Background layer to show through. This creates an impressed effect on the letters. Choose Select, Deselect (Ctrl/Command+D) to remove the selection marquee.

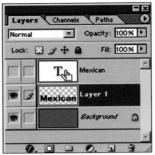

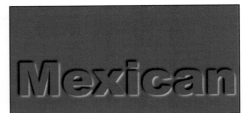

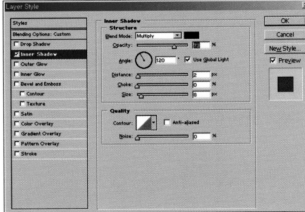

## STEP 7. Adding Inner Shadows to the Text

Click the text layer thumbnail in the Layers palette, and use the Character palette to change the text color to a dark brown, similar to the color on the Background layer. Click the Add a layer style button in the Layers palette, and then click Inner Shadow. Adjust the settings in the Layer Style dialog box as shown here, and then click OK to create a shadow within the letters on the text layer.

## STEP 8. Increasing the Image Size

Next, increase the image size so it can be used as a menu for a Mexican restaurant. Choose Image, Canvas Size from the menu bar. In the Canvas Size dialog box, set the Height to 1200 pixels. Click on the top-center button in the Anchor diagram, and then click OK. Anchoring the top of the canvas causes the new space to be added at the bottom of the image. Click the Eyedropper tool in the toolbox, and then click the brown background area to set it

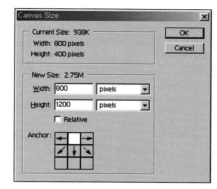

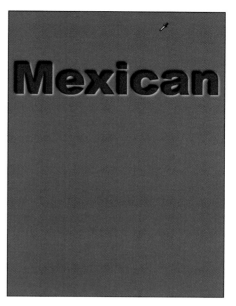

as the foreground color. Click the Background layer in the Layers palette, and press Alt/Option+Del to fill the whole canvas with the brown color.

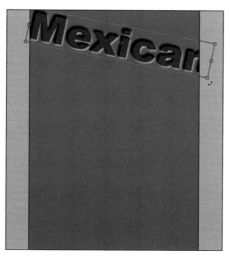

## STEP 9. Rotating the Text

Click the text layer thumbnail in the Layers palette, and then click the empty box next to the Layer 1 layer below it so that a chain link appears, indicating that the two layers are now linked. Now, each time you move the text layer contents, the contents on the Layer 1 layer below it will move as well. Choose Edit, Free Transform (Ctrl/Command+T) from the menu bar. Use the selection handles that appear around the text to resize, rotate, and reposition it as shown here. Press Enter/Return to finish the transformation.

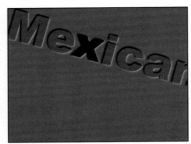

## STEP 10. Changing a Letter's Color

With the type layer still selected, choose the Horizontal Type tool from the toolbox. Select the letter "x" in the text, and then use the Character palette to specify a darker color for the letter. Click the Commit any current edits button on the Options bar to apply the new color to the selected letter. Then, click the eye icon beside the text layer to hide it.

## STEP 11. Entering the Rest of the Text

Now use the Horizontal Type tool to enter the rest of the menu text. First, add the word "dinner" in white and italics near the top of the menu, and then click the Commit any current edits button. Drag on the bottom of the image to define an area to hold the rest of the menu text. Choose the desired font and size in the Character palette, and then click the Paragraph tab in the palette window to display the Paragraph palette. Click the Justify all button there, type the remaining menu text, and then click the Commit any current edits button. After selecting each new text layer in the Layers palette, click on the Add a layer style button, click Drop Shadow, and then click OK.

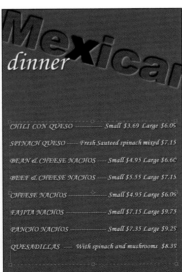

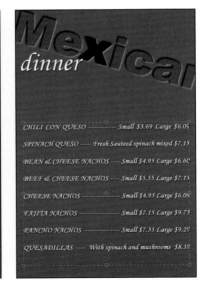

## STEP 12. Adding a Cloud Texture

In the Layers palette, click the eye icon beside all displayed text layers, as well as the Layer 1 layer, to hide those layers. Click on the Background layer thumbnail to select that layer, and then click the Create a new layer button (Shift+Ctrl/Command+N) to add a new layer (named Layer 2) above the Background layer. Double-click on the new layer's name, type "Stone" as the new name, and then press Enter/Return. Click the Default Foreground and Background Colors button on the toolbox to reset the foreground color to black and the background color to white. Choose Filter, Render, Clouds from the menu bar to create a cloud texture on the new layer.

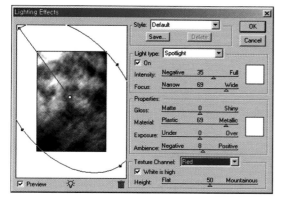

## STEP 13. Applying Directional Lighting to the Cloud Texture

With the Stone layer still selected, choose Filter, Render, Lighting Effects from the menu bar to open the Lighting Effects dialog box. Adjust the handles in the Preview area as shown here to redirect the "light" to shine from the upper-left corner. Choose Red from the Texture Channel drop-down list to add more shading, and then click OK.

## STEP 14. Blending the Cloud Texture

With the Stone layer still selected, click the Add a layer style button at the bottom of the Layers palette, and then click Blending Options. Choose Linear Light from the Blend Mode drop-down list. Reduce the Fill Opacity setting to 36% to reduce the contrast in the texture. Click OK. The gray stone texture blends with the brown layer below it to create a very realistic rocklike texture.

### STEP 15. Completing the Image

Click on the eye icon beside all hidden layers to redisplay them. Select the original text layer (with the text "Mexican"). Click the Add a layer style button on the Layers palette, and click Blending Options. Choose Multiply from the Blend Mode drop-down list, set the Fill Opacity value to 85%, and then click OK. Click the Layer 1 layer to select it, click the Add a layer style button, choose Linear Light as the Blend Mode, and click OK. The rocklike texture now appears on the large text, creating a sophisticated appearance.

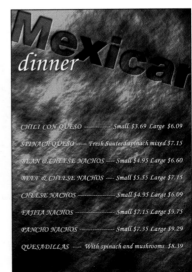

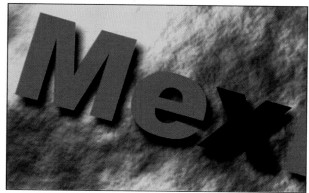

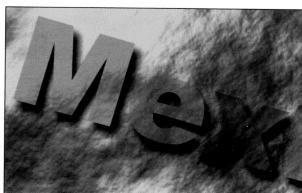

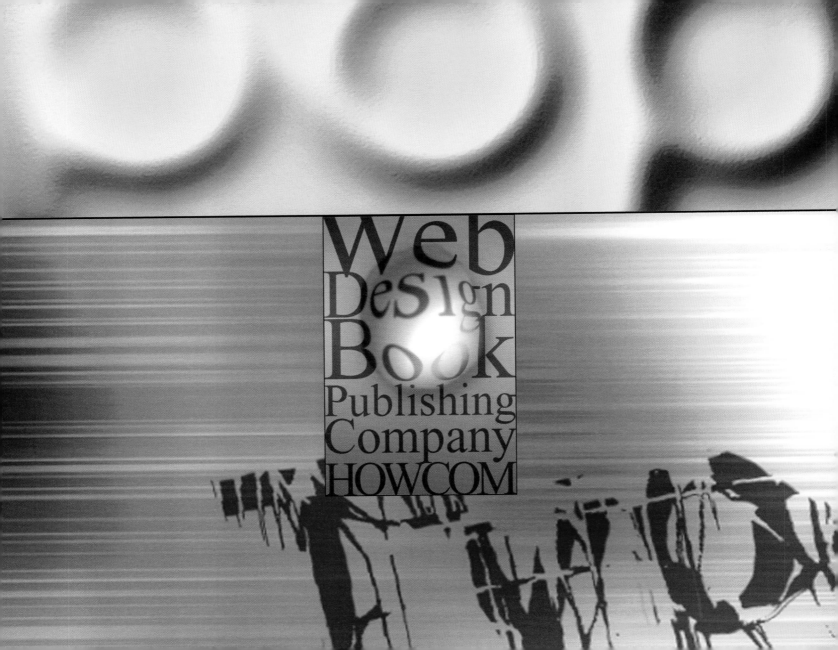

# Project 8: Water Drop Type

In this project, create text that appears to be distorted by a single water drop. Use the Pinch filter to distort the text, and then apply various other techniques to portray the light that shines through the water drop.

Web
Design
Book
Publishing
Company
HOWCOM

Web
Design
Book
Publishing
Company
HOWCOM

**Water Drop Type**

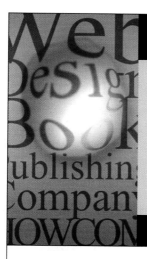

# Project 8: Water Drop Type

## Total Steps

STEP 1.  Making a New Image with a Gray Background

STEP 2.  Making Several Text Layers

STEP 3.  Editing and Resizing Text

STEP 4.  Flattening to the Background Layer

STEP 5.  Creating and Copying in a Water Drop Selection

STEP 6.  Swelling the Water Drop

STEP 7.  Making a White Water Drop Layer

STEP 8.  Softening the Edges of the White Water Drop

STEP 9.  Applying Directional Lighting to the Water Drop

STEP 10. Adding a Shadow to the Water Drop

STEP 11. Softening an Edge of the Water Drop

STEP 12. Selecting the Water Drop Shape Again

STEP 13. Blurring the Inside of the Water Drop

STEP 14. Sharpening the Water Drop Shadow

STEP 15. Applying a Gradient to the Background

STEP 16. Establishing a Blend Mode for the Gradient

## STEP 1. Making a New Image with a Gray Background

Choose File, New (Ctrl/Command+N) from the menu bar to open the New dialog box. Set the image Width to 500 pixels and the Height to 800 pixels. Also set the Resolution to 150 pixels/inch, and then click OK. After setting the foreground color to gray (R:217, G:217, B:217), use the Paint Bucket tool from the toolbox (Alt/Option+Del) to fill the Background layer.

## STEP 2. Making Several Text Layers

Choose the Horizontal Type tool from the toolbox. Display the Character palette (click the Toggle the Character and Paragraph palettes button on the Options bar), and then choose a serif font and a darker gray color. Type the word "Web" in the image window, and then click the Commit any current edits button on the Options bar. Choose the Move tool from the toolbox. Press and hold the Alt/Option key while dragging the word "Web" to copy the text and create a new layer to hold the copy. Use the Alt/Option-drag technique to create five copies of the text.

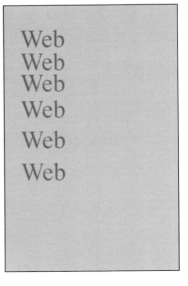

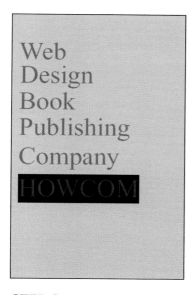

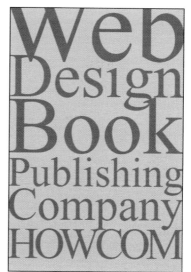

## STEP 3. Editing and Resizing Text

Choose the Horizontal Type tool from the toolbox. To edit each instance of the word "Web," double-click on the word to select it and its layer. Referring to the illustration here, type new text, if needed, and then click the Commit any current edits button on the Options bar. Click the layer for each word in the Layers palette and choose Edit, Transform, Scale. Drag the handles that appear to resize the word to fill the breadth of the image, drag the text to reposition it as needed, and then press Enter/Return.

## STEP 4. Flattening to the Background Layer

Click on the palette menu button in the upper-right corner of the Layers palette, and then choose Flatten Image to combine the text from all the layers onto the Background layer.

**STEP 5.** Creating and Copying a Water Drop Selection

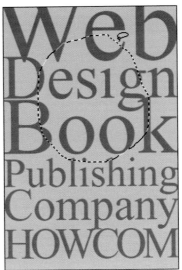

Choose the Lasso Tool from the toolbox.
Select an area in the shape of a water drop in the middle of the image. Choose Select, Feather from the menu bar, set the Feather Radius to 5 pixels, and click OK to soften the edge of the selection. Copy (Ctrl/Command+C) and paste (Ctrl/Command+V) the selected portion. The copied selection automatically appears on a new layer named Layer 1.

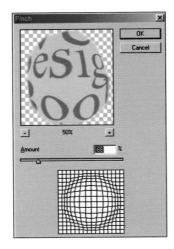

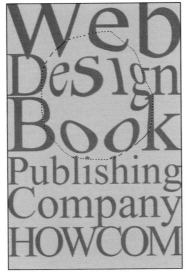

**STEP 6.** Swelling the Water Drop

Ctrl/Command-click on the Layer 1 in the Layers palette to reselect the copied water drop shape. Choose Filter, Distort, Pinch from the menu bar. In the Pinch dialog box, change the Amount setting to -66 to magnify the center of the image, and then click OK.

## STEP 7. Making a White Water Drop Layer

Click the Create a new layer button
(Shift+Ctrl/Command+N) in the Layers palette to add a new
layer. The new layer, Layer 2, will be selected. Set the fore-
ground color to white, and choose the Paint Bucket tool
from the toolbox. Click in the selection marquee or press
Alt/Option+Del to fill the selection.

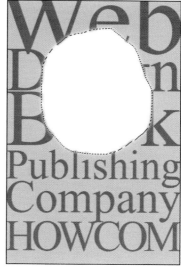

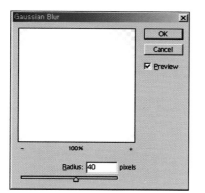

## STEP 8. Softening the Edges of the White Water Drop

Choose Select, Deselect (Ctrl/Command+D)
from the menu bar to remove the selection
marquee. Choose Filter, Blur, Gaussian Blur
from the menu bar. In the Gaussian Blur
dialog box, change the Radius setting to 40
pixels, and then click OK.

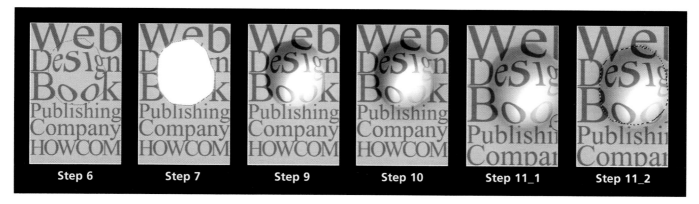

Step 6     Step 7     Step 9     Step 10     Step 11_1     Step 11_2

## STEP 9. Applying Directional Lighting to the Water Drop

Choose Filter, Render, Lighting Effects from the menu bar to open the Lighting Effects dialog box. Adjust the handles in the Preview area as shown here to redi-

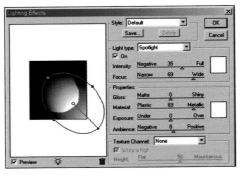

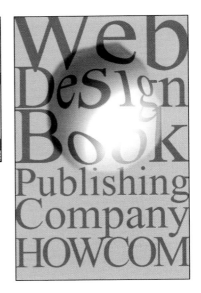

rect the "light" to shine from the lower-right corner. Also make sure None is selected from the Texture Channel drop-down list. Click OK. With Layer 2 still selected in the Layers palette, click the Add a layer style button, and then click Blending Options. Choose Linear Light from the Blend Mode drop-down list, change the Fill Opacity setting to 79%, and then click OK.

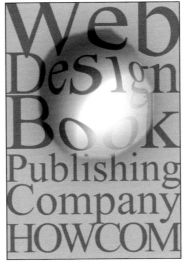

## STEP 10. Adding a Shadow to the Water Drop

With Layer 2 still selected in the Layers palette, click the Add a layer style button, and then click Drop Shadow. In the Layer Style dialog box, choose the settings shown here, and then click OK.

## STEP 11. Softening an Edge of the Water Drop Shadow

The lower-right edge of the water drop shadow layer (Layer 2) is too strong. Leave that layer selected, and choose the Eraser tool from the toolbox. Click on the Click to open the Brush Preset picker button on the Options bar. Choose the Soft Round 100 pixels brush, and then press Enter/Return to close the preset picker. Also reduce the Opacity setting on the Options bar to 25%. Then, drag the brush over the lower-right edge of the shadow layer content as shown here to blend and soften the shadow.

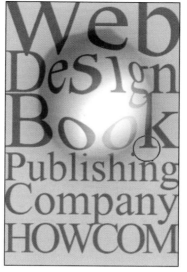

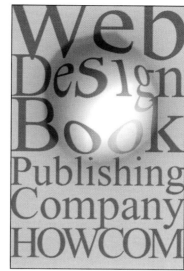

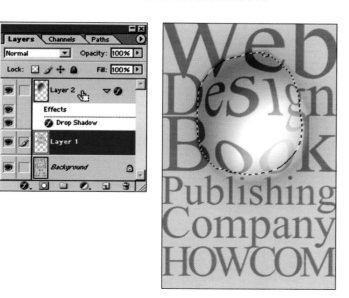

## STEP 12. Selecting the Water Drop Shape Again

Click Layer 1 in the Layers palette to select that layer. Then, Ctrl/Command-click Layer 2 to make a selection on Layer 1 in the shape of Layer 2's content.

## STEP 13. Blurring the Inside of the Water Drop

Choose Filter, Blur, Gaussian Blur from the menu bar to open the Gaussian Blur dialog box. Change the Radius setting to 3 pixels, and then click OK. This blurs the text seen through the water drop.

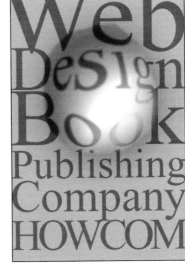

## STEP 14. Sharpening the Water Drop Shadow

The blurry shadows on the edge of the water drop make it appear too indistinct. Adding a second shadow will make the water drop appear more pronounced. Click Layer 1 in the Layers palette to select that layer. Click the Add a layer style button at the bottom of the palette, and then click Drop Shadow. Adjust the settings in the Layer Style dialog box as shown here, and then click OK to add a shadow inside the previous shadow. Choose Select, Deselect (Ctrl/Command+D) to remove the selection marquee. Then, click the eye icon beside Layer 1 and Layer 2 to hide each layer.

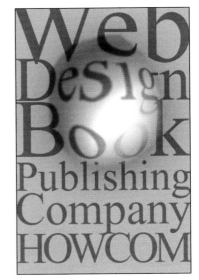

## STEP 15. Applying a Gradient to the Background

Click the Background layer in the Layers palette, and then click the Create a new layer button (Ctrl/Command+N) to add a new layer (Layer 3) above the Background layer. Click the Switch Foreground and Background Colors button on the toolbox to reset the foreground color to white and the background color to black. Choose the Gradient tool from the toolbox, and then click the Reflected Gradient button on the Options bar. Then, drag straight down from the center of the image window beyond the bottom of the window to apply the gradient. (Press and hold the Shift key while dragging to keep the direction straight.) You can then redisplay Layer 1 and Layer 2 by clicking the eye icon box beside each.

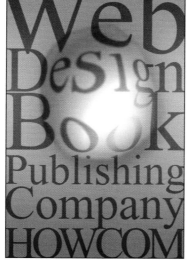

## STEP 16. Establishing a Blend Mode for the Gradient

With Layer 3 still selected in the Layers palette, click the Add a layer style button, and then click Blending Options. In the Layer Style dialog box, Choose Linear Burn from the Blend Mode drop-down list. Also change the Fill Opacity setting to 33%, and then click OK. This will darken the outer portions of the Background layer to create a deeper effect.

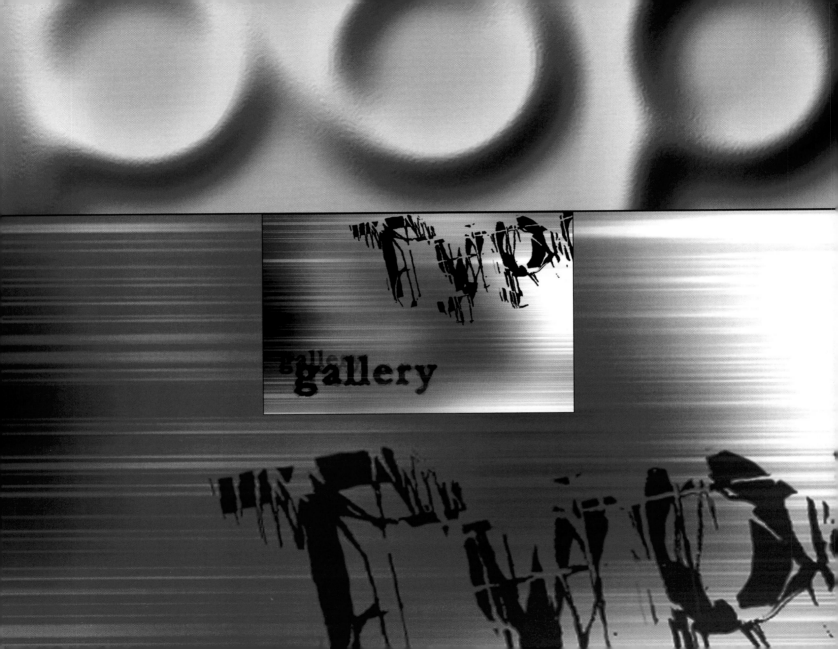

gallery

# Project 9: Grunge Type

You can create messy text using the Displace filter. This technique enables you to incorporate text into the texture for the image.

Grunge Type

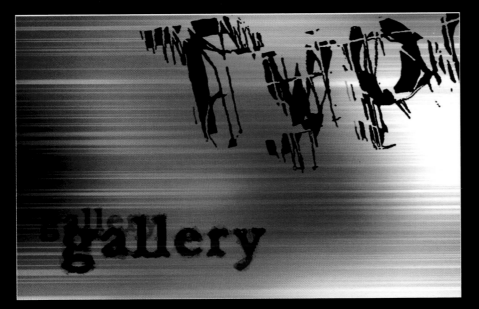

# Project 9: Grunge Type

## Total Steps

STEP 1.    Creating an Image with Lines

STEP 2.    Saving the File for Use as a Displace Map

STEP 3.    Entering Text in a New File

STEP 4.    Transforming the Text Using a Displace Filter

STEP 5.    Entering More Text

STEP 6.    Adding a Text-Shaped Selection to a New Layer

STEP 7.    Blurring the Text

STEP 8.    Texturing the Text

STEP 9.    Adjusting the Color of the Rough Text

STEP 10.   Importing a Background Image

STEP 11.   Blurring the Background Image and Changing Its Color

STEP 12.   Adding a White Layer

STEP 13.   Applying Noise to the Layer

STEP 14.   Clumping the Noise Speckles

STEP 15.   Stretching the Noise Texture

STEP 16.   Lightening the Noise Effect

STEP 17.   Completing the Image

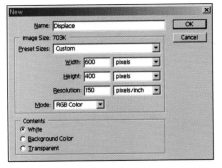

## STEP 1. Creating an Image with Lines

Choose File, New (Ctrl/Command+N) from the menu bar to open the New dialog box. Set the Width to 600 pixels and the Height to 400 pixels. Also set the Resolution to 150 pixels/inch, and then click OK. Choose the Brush tool from the toolbox, and click the Click to open the Brush Preset picker button on the Options bar. Choose the Hard Round 3 pixels brush, and press Enter/Return to close the preset picker. Set the foreground color to black, and draw vertical and horizontal lines as shown here.

## STEP 2. Saving the File for Use as a Displace Map

Choose Filter, Artistic, Cutout from the menu bar to open the Cutout dialog box. Change the No. of Levels and Edge Simplicity settings as shown here, and then click OK. Gray surfaces will enhance the pattern of lines, as shown here. Choose File, Save (Ctrl/Command+S) from the menu bar, and save the image as a Photoshop (*.psd) file. You will use this image as a displace map source file. For your convenience, you can instead use the source file offered on the supplementary CD-ROM (Book\Sources\Disp-grunge.psd). Close the file that you've created.

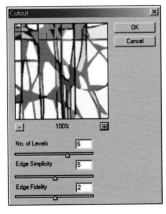
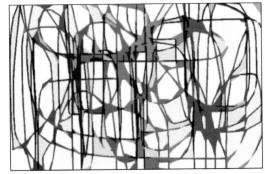

## STEP 3. Entering Text in a New File

Make an image by choosing File, New (Ctrl/Command+N) from the menu bar. Set the Width to 600 pixels, the Height to 400 pixels, and the resolution to 150 pixels/inch. Click OK. Set the foreground color to black, and then choose the Horizontal Type tool from the toolbox. Click the Toggle the Character and Paragraph palettes button on the Options bar, and choose the palette settings shown here. Type the word "Typo" in the image window, and then click the Commit any current edits button on the Options bar.

## STEP 4. Transforming the Text Using a Displace Filter

Choose Edit, Free Transform (Ctrl/Command+T) from the menu bar, drag the handles to increase the text to fill the window as shown here, and then press Enter/Return. Choose Filter, Distort, Displace from the menu bar. Click OK when Photoshop asks whether to rasterize the type. In the Displace dialog box that opens, specify the settings shown here, and then click OK. Use the Choose a displacement map dialog box that appears to select the Photoshop (*.psd) file you saved in Step 2, or the Disp-grunge.psd file. Click Open to transform the text using the displace map file.

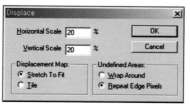

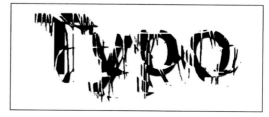

## STEP 5. Entering More Text

Choose Edit, Transform, Rotate from the menu bar. Drag outside the selection handles to rotate the beginning of the text downward, and drag within the text to move it to the upper-right corner of the window. Press Enter/Return to finish the transformation. Choose the Horizontal Type tool, specify the font settings shown here in the Character palette, and then type the word "gallery" in the lower-left corner of the image. Click the Commit any current edits button at the right end of the Options bar to finish adding the text.

## STEP 6. Adding a Text-Shaped Selection to a New Layer

Click the Create a new layer button (Shift+Ctrl/Command+N) in the Layers palette to add a new layer named Layer 1 above the text layer (the gallery layer) you just created. Set the foreground color to white, and press Alt/Option+Del to fill the new layer with white. Ctrl/Command-click the gallery layer in the Layers palette to add a selection marquee in the shape of the letters. Set the foreground color to black, and then press Alt/Option+Del to color the text black. Choose Select, Deselect (Ctrl/Command+D) to remove the selection marquee.

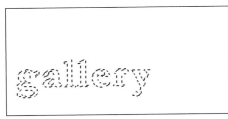

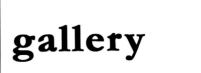

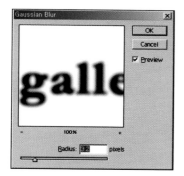 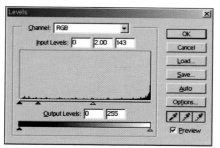 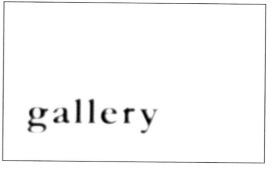

## STEP 7. Blurring the Text

Choose Filter, Blur, Gaussian Blur from the menu bar to open the Gaussian Blur dialog box. Change the Radius setting to approximately 3.2, and then click OK. Choose Image, Adjustments, Levels to open the Levels dialog box. Drag the center and rightmost Input Levels sliders to the settings shown here, and then click OK. These settings combine to blur and thin letters.

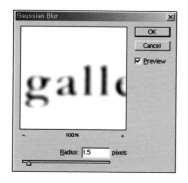 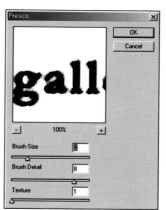 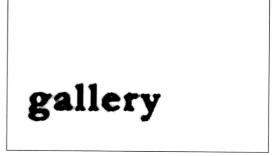

## STEP 8. Texturing the Text

With the Layer 1 layer still selected in the Layers palette, choose Filter, Blur, Gaussian Blur from the menu bar. Reduce the blur Radius to 1.5, and then click OK. Choose Filter, Artistic, Fresco, and then choose the settings shown here in the Fresco dialog box. Click OK to finish roughing or texturing the edges of the letters.

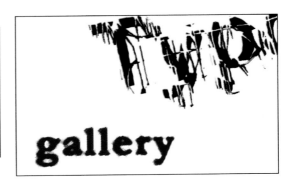

## STEP 9. Adjusting the Color of the Rough Text

Choose Image, Adjustments, Hue/Saturation (Ctrl/Command+U) from the menu bar to open the Hue/Saturation dialog box. Click the Colorize check box to check it, drag the three color sliders to the settings shown here, and then click OK. The black letters will take on a bluish tone. Click the Add a layer style button on the Layers palette, and then click Blending Options. Choose Multiply from the Blend Mode drop-down list, and then click OK.

## STEP 10. Importing a Background Image

Choose File, Open (Ctrl/Command+O), and open the Book\Sources\Entrance.jpg file from this book's

supplementary CD-ROM. Choose Select, All (Ctrl/Command+A) to select the entire image. Press Ctrl/Command+C to copy the selection, and close the file.

Return to the image file you created for this project, and then press Ctrl/Command+V to paste the copied image onto a new layer named Layer 2. In the Layers palette, drag Layer 2 down and place it just above the Background layer. Choose Edit, Transform, Rotate 90°CW to rotate the copied image. Then choose Edit, Free Transform (Ctrl/Command+T), drag the handles to resize the layer content to fill the image window, and then press Enter/Return.

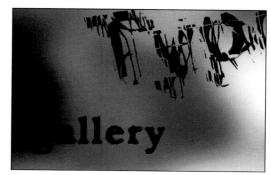

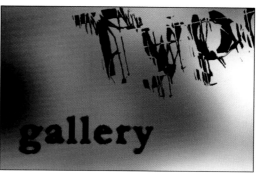

## STEP 11. Blurring the Background Image and Changing Its Color

With the Layer 2 layer still selected in the Layers palette, choose Filter, Blur, Gaussian Blur from the menu bar. In the Gaussian Blur dialog box, increase the Radius setting to 40, and then click OK. This blurs the image so only its original colors can be seen. Choose Image, Adjustments, Variations to open the Variations dialog box. Click the More Green and More Yellow thumbnails in the dialog box to add more greenish tones into the layer, and then click OK.

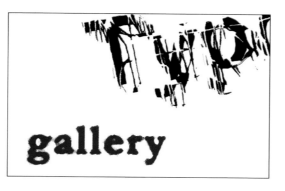

## STEP 12. Adding a White Layer

Click the Create a new layer button (Ctrl/Command+N) in the Layers palette to add a new layer named Layer 3. Leave it positioned above Layer 2. Set the foreground color to white, and press Alt/Option+Del to fill the new layer with white. Click on the eye icon beside each of the layers above Layer 3 in the Layers palette to hide them.

## STEP 13. Applying Noise to the Layer

With Layer 3 still selected, choose Filter, Noise, Add Noise from the menu bar. In the Add Noise dialog box, increase the Amount setting to approximately 115, and click the Monochromatic check box to check it. Click OK to fill the layer with noise speckles. Then, choose Filter, Blur, Gaussian Blur from the menu bar. Change the Radius setting to approximately 2.7, and then click OK. The speckles now blur together.

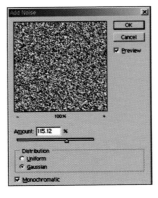
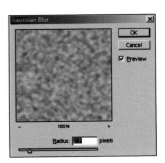

## STEP 14. Clumping the Noise Speckles

With Layer 3 still selected, choose Image, Adjustments, Levels (Ctrl/Command+L) from the menu bar to open the Levels dialog box.

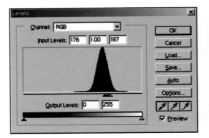
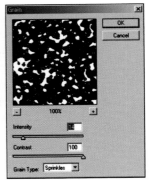

Drag the left and right Input Levels sliders toward the center to the positions shown here and then click OK to create a sharp black and white image. Then, choose Filter, Texture, Grain. Choose the settings shown here in the Grain dialog box, and then click OK to add white noise to the black areas in the image.

## STEP 15. Stretching the Noise Texture

Using the Rectangular Marquee tool, select a vertical rectangle in the image. Choose Edit, Free Transform (Ctrl/Command+T), drag the left and right handles that appear on the selection to stretch the selection horizontally to fill the layer, and then press Enter/Return. Choose Select, Deselect (Ctrl/Command+D) to remove the selection marquee.

## STEP 16. Lightening the Noise Effect

With Layer 3 still selected, choose Filter, Blur, Motion Blur from the menu bar. In the Motion Blur dialog box, set the Angle to 0 and the Distance to 564, and then click OK. Then, click the Add a layer style button on the Layers palette, and click Blending Options. Choose Overlay from the Blend Mode drop-down list, set the Fill Opacity to 61%, and then click OK. This will blend the horizontal stripes of light to the background image.

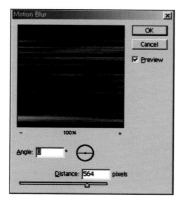

## STEP 17. Completing the Image

In the Layers palette, drag the gallery text layer onto the Delete layer button to delete the layer from the image. Click on the box for the eye icon beside each of the hidden layers to redisplay it. Click the Layer 1 layer to select it, and choose Layer, New, Layer via Copy (Ctrl/Command+J). Click the Layer 1 copy layer in the Layers palette. Use the Move tool to move the layer content, and the Edit, Free Transform command to reduce its size. Also use the Opacity setting on the Layers palette to make the text copy more transparent to complete the image.

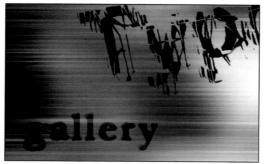
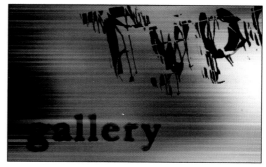

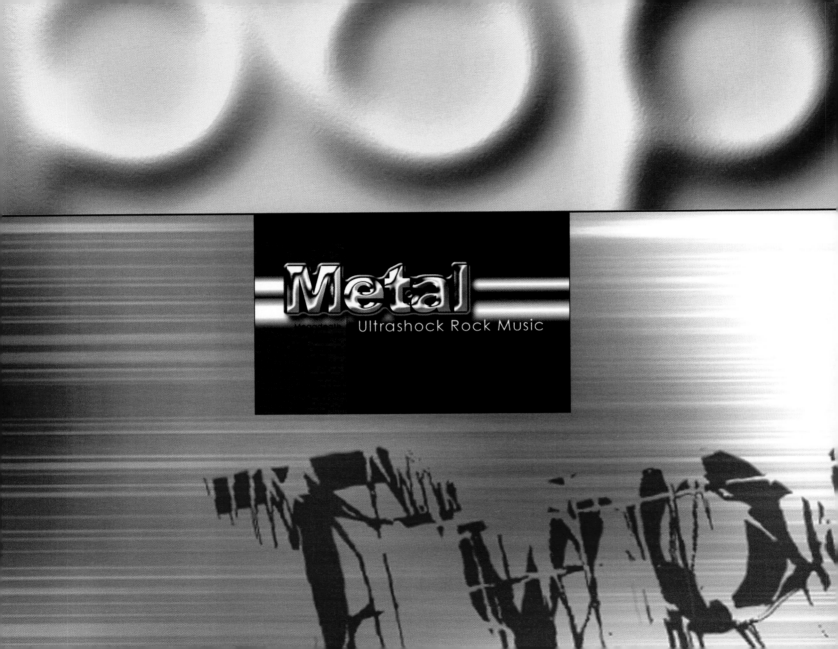

# Project 10: Rounded Metal Type

In this project, learn to use the Lighting Effects filter and the Curve command to create highly realistic 3-D metallic text. You could use the completed text—a strong, monotone image—as the main image for a Web page.

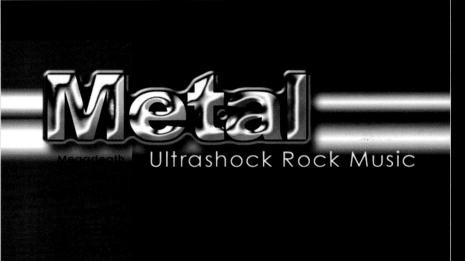

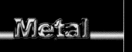

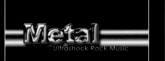

# Project 10: Rounded Metal Type

## Total Steps

STEP 1.  Making a New Image

STEP 2.  Adding a Background and White Text

STEP 3.  Adding a Cloud Texture Layer

STEP 4.  Making an Alpha Channel from a Text Selection

STEP 5.  Observing the Alpha Channel

STEP 6.  Softening the Alpha Channel Boundaries

STEP 7.  Applying Directional Lighting to the Cloud Texture

STEP 8.  Removing Areas Outside the Text

STEP 9.  Making the Text Metallic

STEP 10. Making a Text-Shaped Selection

STEP 11. Adjusting the Border Edges

STEP 12. Creating a Pipe Shape Layer

STEP 13. Making the Pipe in the Background

STEP 14. Copying the Pipe in the Background

STEP 15. Entering the Subtitle

STEP 16. Making a Rectangular Frame for the Text

STEP 17. Cropping the Image

## STEP 1. Making a New Image

Choose File, New (Ctrl/Command+N) from the menu bar to open the New dialog box. Set the Width to 800 pixels and the Height to 600 pixels. Also set the Resolution to 150 pixels/inch, and then click OK.

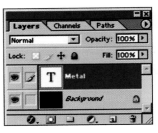

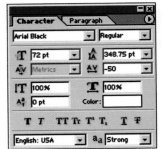

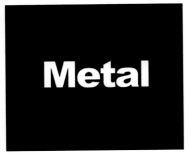

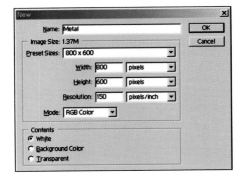

## STEP 2. Adding a Background and White Text

Click the Default Foreground and Background Colors button on the toolbox to reset the foreground color to black and the background color to white. Then, use the Paint Bucket tool or press Alt/Option+Del to fill the Background layer with black. Choose the Horizontal Type tool from the toolbox. Click the Toggle the Character and Paragraph palettes button on the Options bar to open the Character palette, if needed. Choose the settings shown here in the Character palette, type the word "Metal" in the image window, and then click the Commit any current edits button on the Options bar.

## STEP 3. Adding a Cloud Texture Layer

Click the Default Foreground and Background Colors button on the toolbox to reset the foreground color to black and the background color to white. Click the Create a new layer button (Shift+Ctrl/Command+N) on the Layers palette to make a new layer named Layer 1. Choose Filter, Render, Clouds from the menu bar to fill the new layer with a cloud texture.

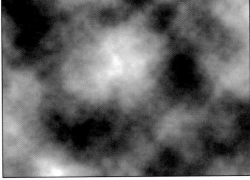

## STEP 4. Making an Alpha Channel from a Text Selection

With Layer 1 still selected in the Layers palette, Ctrl/Command-click the text layer to make a selection in the shape of the letters. Display the Channels palette (Window, Channels) and click the Save selection as channel button at the bottom of the palette. A new alpha channel named Alpha 1 appears at the bottom of the palette. Choose Select, Deselect (Ctrl/Command+D) to remove the selection marquee.

## STEP 5. Observing the Alpha Channel

Click the Alpha 1 channel in the Channels palette. The alpha channel content appears in the image window, where you could edit it. You can use an alpha channel, a black and white image saved separately from the image color channels, to save and reload a selection. Clicking on the Save selection as channel button in the Channels palette saves a selection as an alpha channel. If you click an alpha channel in the Channels palette and then click the Load channel as selection button at the bottom of the palette, a selection marquee will appear around the white areas of the alpha channel.

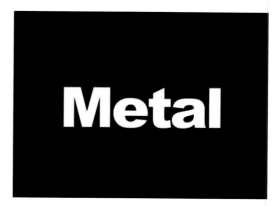

## STEP 6. Softening the Alpha Channel Boundaries

With the Alpha 1 channel selected in the Channels palette, choose Filter, Blur, Gaussian Blur from the menu bar. In the Gaussian Blur dialog box, change the Radius setting to 7, and then click OK. This blurs the alpha channel image, resulting in a blurred selection when you load the alpha channel as a selection. Click the RGB channel in the Channels palette to redisplay the color channels and deselect the alpha channel.

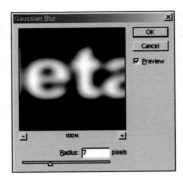

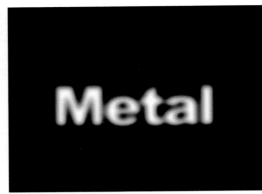

## STEP 7. Applying Directional Lighting to the Cloud Texture

Redisplay the Layers (Window, Layers), and then click the Layer 1 layer to select it. Choose Filter, Render, Lighting Effects to open the Lighting Effects dialog box. Adjust the handles in the Preview area as shown here to redirect the "light" to shine from the upper-left corner. Choose Alpha 1 from the Texture Channel drop-down list, and then click OK. The light effect makes the letters (specified by the alpha channel's shape) appear to protrude from the cloudy background.

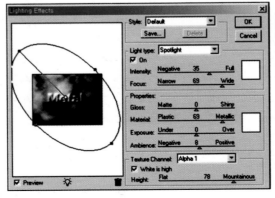

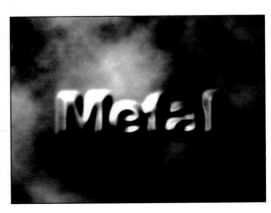

## STEP 8. Removing Areas Outside the Text

Click on the eye icon beside the text (Metal) layer in the Layers palette to hide the layer. Then, with Layer 1 still selected in the Layers palette, Ctrl/Command-click on the text layer to display a selection marquee in the shape of the letters from the text layer. Choose Select, Inverse (Shift+Ctrl/Command+I) from the menu bar to invert the selection marquee. Press the Del key to remove the cloud texture from the areas outside the text selection. This creates three-dimensional text. Choose Select, Deselect (Ctrl/Command+D) to remove the selection marquee.

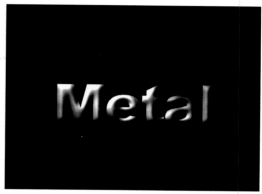

## STEP 9. Making the Text Metallic

With Layer 1 still selected, choose Image, Adjustments, Curves (Ctrl/Command+M). In the Curves dialog box, bend the curve into the shape shown here. To do so, click the diagonal line to create two points on the curve, and then drag them into position. Click OK to apply the changes to the image. The simple 3-D text now takes on a metallic appearance.

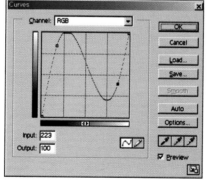

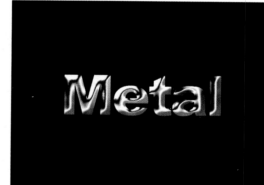

### STEP 10. Making a Text-Shaped Selection

Now make a border for the text. With Layer 1 still selected, Ctrl/Command-click the Metal layer in the Layers palette to make a selection in the shape of the letters.

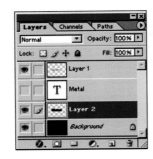
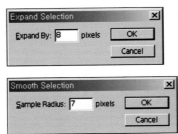
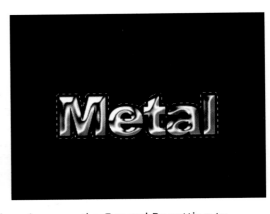

Choose Select, Modify, Expand from the menu bar. In the Expand Selection dialog box, increase the Expand By setting to 8, and then click OK. The selection marquee expands by eight pixels in all directions. Choose Select, Modify, Smooth. In the Smooth Selection dialog box, set the Sample Radius to 7 pixels, and then click OK to soften the sharp edges of the selection frame. Click the Background layer in the Layers palette, press Ctrl/Command+C to copy the selected area, and then press Ctrl/Command+V to paste the copied selection into a new layer named Layer 2.

### STEP 11. Adjusting the Border Edges

Click the Layer 2 layer in the Layers palette, and then click the Add a layer style button. Click Bevel and Emboss in the menu that appears. Choose Screen from the Shadow Mode drop-down list. Click the color box beside the Shadow Mode drop-down list, choose a gray color in the Color Picker dialog box, and click OK. A gray border appears around the text to enhance the metallic texture of the letters.

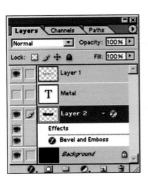
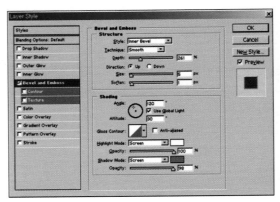
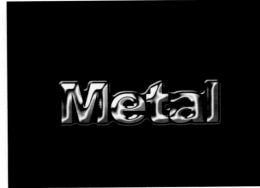

## STEP 12. Creating a Pipe Shape Layer

Next create a layer to hold a horizontal pipe image in the background. Click the Create a new layer button (Shift+Ctrl/Command+N) in the Layers palette to make a new layer. Double-click the layer name, type "Pipe," and press Enter/Return to rename the layer. Drag the Pipe layer down to place it right above the Background layer. Use the Rectangular Marquee tool from the toolbox to make a long, rectangular selection horizontally across the image, as shown here.

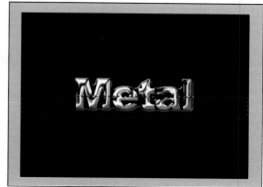

## STEP 13. Making the Pipe in the Background

After setting the foreground color to white and the background color to black, choose the Gradient tool from the toolbox. Click the Reflected Gradient button on the Options bar at the top. Drag from the center of the selection frame straight down to the edge of the selection frame. The gradient makes the selection appear like a protruding, white pipe image.

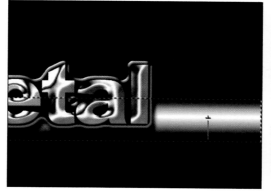

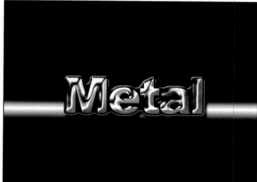

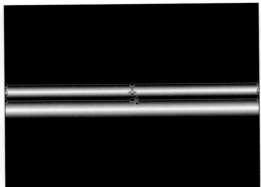
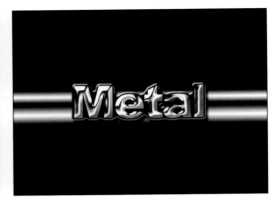

## STEP 14. Copying the Pipe in the Background

With the Pipe layer selected in the Layers palette, choose Layer, New, Layer via Copy (Ctrl/Command+J). A new layer named Layer 3 appears and is selected. Choose Edit, Free Transform (Ctrl/Command +T). Drag the handles to slightly reduce the vertical height of the copied pipe object, and press Enter/Return. Then use the Move tool from the toolbox to move the copied pipe above the original pipe image, as shown here. Click Layer 2 (the text border layer) in the Layers palette, click the Add a layer style button, and then click Drop Shadow. Click OK to apply the shadow.

## STEP 15. Entering the Subtitle

Choose the Horizontal Type tool from the toolbox. Specify the settings shown here in the Character palette, and then type in the white subtitle. Click the Commit any current edits button to finish adding the subtitle.

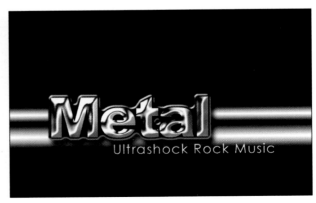

## STEP 16. Making a Rectangular Frame for the Text

Use the Horizontal Type tool from the toolbox to add the list of bands shown in the lower-left corner of the image here. Use black or dark-gray text. Then, make a new layer and move it above the Pipe layer and its copy. Choose the Rectangle tool from the toolbox, click the Fill Pixels button on the Options bar, set the foreground color to white, and draw a box to cover the list of bands. Blend it into the image by clicking the Add a layer style button, and clicking Blending Options. Choose Linear Light from the Blend Mode drop-down list, set the Fill Opacity value to 28%, and click OK.

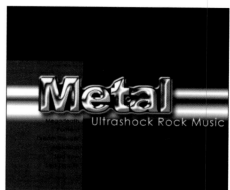

## STEP 17. Cropping the Image

Use the Rectangular Marquee tool to select the desired portion of the final image, and then choose Image, Crop from the menu bar. If desired, change the color of the black Background layer to a dark gray to enhance the metallic letters.

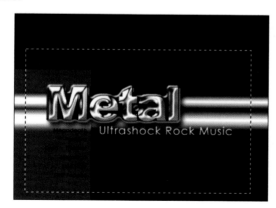
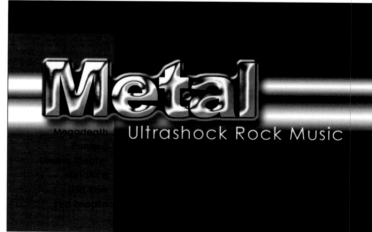

point-of-purchase

# Project 11: Caught in a Net

In this project, create text with effects that make the text appear to be caught in a net. Learn how to use the Displace filter to bend the lines in the net to fit the text.

## Caught in a Net

# Project 11: Caught in a Net

## Total Steps

STEP 1.   Making a New Image with a Gray Background

STEP 2.   Entering Text

STEP 3.   Resizing and Blurring the Text

STEP 4.   Adding a New White Layer

STEP 5.   Making a Black Square

STEP 6.   Creating the Grid Pattern

STEP 7.   Applying the Grid Pattern

STEP 8.   Inverting the Text Color

STEP 9.   Changing the Text Color

STEP 10.  Adding 3-D Contours to the Text

STEP 11.  Selecting the Spider Layer

STEP 12.  Adjusting the Grid Pattern Color

STEP 13.  Applying the Displace Filter to the Grid

STEP 14.  Enhancing Shadows in the Spider Web Image

STEP 15.  Fading the Shadows

STEP 16.  Overlapping Text Layers

STEP 17.  Brightly Blending the Text Layers

STEP 18.  Entering the Remaining Text

STEP 19.  Adding Contrast Above and Below the Text

STEP 20.  Completing the Image

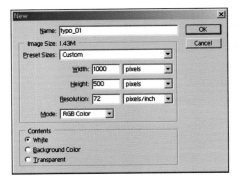

## STEP 1. Making a New Image with a Gray Background

Choose File, New (Ctrl/Command+N) from the menu bar to open the New dialog box. Set the Width to 1000 pixels, the Height to 500 pixels, and the Resolution to 72 pixels/inch. Click OK. Use the Color palette to set the foreground color to a medium gray (R:128, G:128, B:128), and then use the Paint Bucket tool or press Alt/Option+Del to fill the Background layer with the gray color.

## STEP 2. Entering Text

Choose the Horizontal Type tool from the toolbox. Open the Character palette by clicking the Toggle the Character and Paragraph palettes button on the Options bar. In the Character palette, choose the font settings shown here. (If the KaratMedium font is not available, choose a similar sans serif font.) Click in the image window, enter the text as shown, and click the Commit any current edits button on the Options bar.

## STEP 3. Resizing and Blurring the Text

Choose Edit, Free Transform (Ctrl/Command+T) from the menu bar. Drag the handles that appear to increase the size of the text so it fills the image

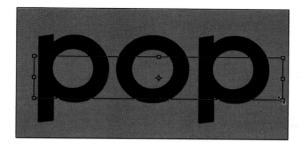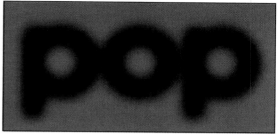

window. Press Enter/Return to finish the transformation. Choose Filter, Blur, Gaussian Blur from the menu bar. Click OK in the dialog box that prompts you to rasterize the text. In the Gaussian Blur dialog box, set the Radius to 20, and then click OK to blur the image. Use File, Save (Ctrl/Command+S) to save the current file as a pop.psd. You will use this file as the Displace map. For your convenience, the file is included on the supplementary CD-ROM (Book\Sources\pop.psd).

## STEP 4. Adding a New White Layer

Click the Create a new layer button (Shift+Ctrl/Command+N) in the Layers palette to add a new layer. Double-click the layer name, type "spider," and then press Enter/Return to rename the layer. Set the foreground color to white, and then use the Paint Bucket tool or press Alt/Option+Del to fill the layer with white.

## STEP 5. Making a Black Square

You next need to make a grid (which
you'll later transform to a spider web)
on the new spider layer. To start,
choose the Rectangular Marquee tool
from the toolbox. Press and hold the
Shift key, and then drag on the white
spider layer to create a square selec-
tion frame. Set the foreground color
to black. Choose Edit, Stroke from the
menu bar, increase the Width setting

to 2 px and click the Inside option button in the Stroke dialog box, and then
click OK. This creates a black outline around the square selection.

## STEP 6. Creating the Grid Pattern

With the square still selected, convert it into
a pattern. Choose Edit, Define Pattern from
the menu bar. Type a pattern Name, if
desired, and then click OK.

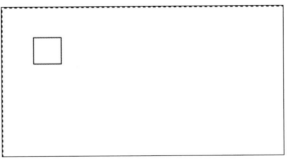

## STEP 7. Applying the Grid Pattern

Choose Select, All (Ctrl/Command+A)
to select the entire spider layer.
Choose Edit, Fill from the menu bar
to open the Fill dialog box. Choose
Pattern from the Use drop-down list,
and then choose the pattern you
created in Step 6 from the Custom
Pattern palette. Click OK to fill the
selection with a grid of black lines.
Choose Select, Deselect
(Ctrl/Command+D) to remove the
selection marquee.

## STEP 8. Inverting the Text Color

In the Layers palette, drag the spider layer to place it below the text (pop)
layer. Click the pop layer to select it. Choose Image, Adjustments, Invert
(Ctrl/Command+I) to invert the color of the text from black to white.

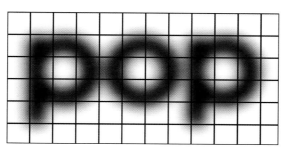

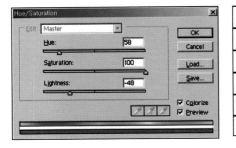

### STEP 9. Changing the Text Color

Choose Image, Adjustments, Hue/Saturation (Ctrl/Command+U) from the menu bar. In the Hue/Saturation dialog box settings, click the Colorize check box to check it, and then choose the Hue, Saturation, and Lightness settings shown here. Click OK to apply the color change to the text.

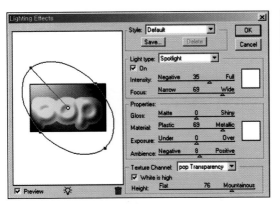

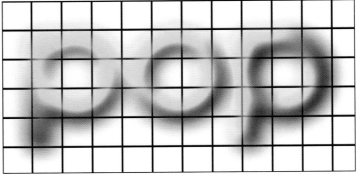

### STEP 10. Adding 3-D Contours to the Text

With the pop layer still selected, choose Filter, Render, Lighting Effects from the menu bar. Adjust the handles in the Preview area as shown here to redirect the "light" to shine from the upper-left corner. Choose pop Transparency from the Texture Channel drop-down list, and then click OK. The softened edges of the text make the contours appear natural.

## STEP 11. Selecting the Spider Layer

You next need to adjust the color of the grid pattern you applied earlier to the spider layer. To start, click the spider layer in the Layers palette to select that layer.

## STEP 12. Adjusting the Grid Pattern Color

Choose Image, Adjustments, Hue/Saturation (Ctrl/Command+U) from the menu bar. In the Hue/Saturation dialog box settings, click the Colorize check box to check it, and then choose the Hue, Saturation, and Lightness settings shown here. Click OK to apply the color change to the grid.

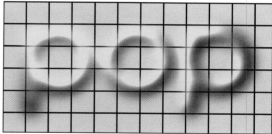

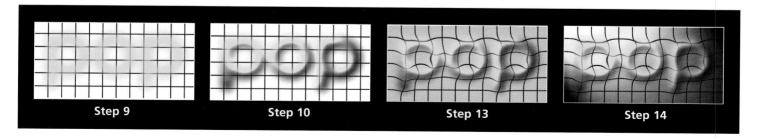

Step 9

Step 10

Step 13

Step 14

## STEP 13. Applying the Displace Filter to the Grid

With the spider layer still selected, choose Filter, Distort, Displace from the menu bar. Choose the settings shown here in the Displace dialog box, and then click OK. In the Choose a displacement map dialog box, select the pop.psd file, and then click Open. (You can choose Book\Sources\pop.psd from the supplementary CD-ROM if you did not save your own file earlier.) When Photoshop applies the color of the Displace map to the spider layer, the lines of the grid bend to follow the brighter colors of the letters in the displace map file.

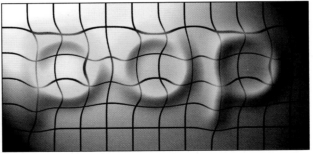

## STEP 14. Enhancing Shadows in the Spider Web Image

With the spider layer still selected in the Layers palette, choose Filter, Render, Lighting Effects. Adjust the handles in the Preview area as shown here to concentrate the "light" shining on the image. Leave None selected from the Texture Channel drop-down list, and then click OK. Darker shadows appear in the lower-left and upper-right corners of the layer.

## STEP 15. Fading the Shadows

Next adjust the intensity of the shadows you just added. Choose Edit, Fade Lighting Effects (Shift+Ctrl/Command+F) from the menu bar. In the Fade dialog box, change the Opacity setting to 45 as shown here, and then click OK.

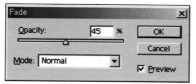

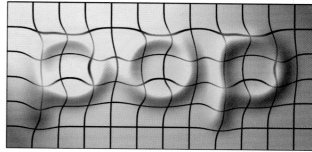

## STEP 16. Overlapping Text Layers

Click the pop text layer to select it. Choose Layer, New, Layer via Copy (Ctrl/Command+J) to copy the layer. Click the original pop layer in the Layers palette to reselect the layer, and then click the Add a layer style button at the bottom of the palette. Click Blending Options in the menu to open the Layer Style dialog box. Choose Linear Burn from the Blend Mode drop-down list, and then click OK. This will darken the blend of the two layers.

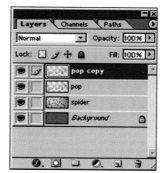

## STEP 17. Brightly Blending the Text Layers

In the Layers palette, click the pop copy text layer. Click the Add a layer style button at the bottom of the palette, and then click Blending Options in the menu. In the Layer Style dialog box, choose Hard Light from the Blend Mode drop-down list. Change the Fill Opacity setting to 61%, and then click OK. This will intensify both the dark and light areas of the layer, making the dark areas darker and the light areas lighter.

## STEP 18. Entering the Remaining Text

Choose the Horizontal Type tool from the toolbox. Adjust the settings in the Character palette as shown here, and then click in the image and enter the remaining text. Click the Commit any current edits button to finish the new text.

Click the Create a new layer button (Shift+Ctrl/ Command+N) in the Layers palette to add a new layer named Layer 1. Use the Rectangular Marquee tool to select the bottom portion of the new layer as shown here.

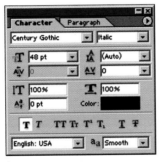

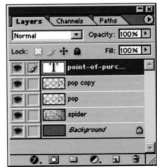

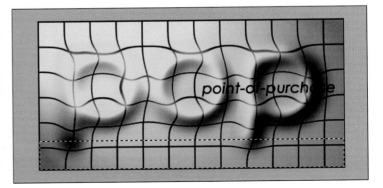

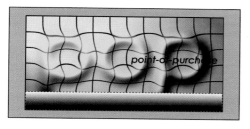 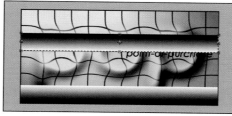 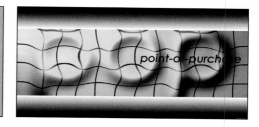

## STEP 19. Adding Contrast Above and Below the Text

Click the Default Foreground and Background Colors button on the toolbox to make the foreground color black and the background color white. Choose the Gradient tool from the toolbox. Click the Linear Gradient button on the Options bar, and then drag from the bottom of the selection frame to the top to fill it with the gradient. Click the Move tool on the toolbox. Press and hold the Alt/Option key while dragging from the center of the selection to copy the selection and move the copy to the top of the image window. Choose Edit, Transform, Rotate 180° to create the effect shown here.

## STEP 20. Completing the Image

Double-click the name of Layer 1 in the Layers palette, type "shadow," and press Enter/Return to rename the layer. Click the Add a layer style button on the Layers palette, and then click Blending Options. In the Layer Style dialog box, choose Multiply from the Blend Mode drop-down list, and then click OK. This blends the gradients on the shadow layer with the layers below to make the darker areas darker.

 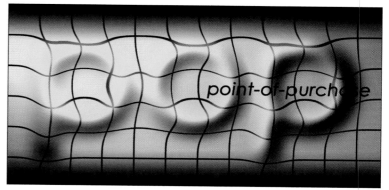

# Project 12: Blur Effect Type

In this project, you will create depth in an image by focusing the foreground text and blurring the background text. The blurred background letters make the foreground text appear as if it's placed on a transparent glass surface.

Blur Effect Type

# Project 12: Blur Effect Type

## Total Steps

STEP 1. Making a New Image with a Sky Blue Background

STEP 2. Entering the Text

STEP 3. Sizing and Realigning the Text

STEP 4. Rasterizing the Text

STEP 5. Blurring the Text Shapes

STEP 6. Blurring the Text Even More

STEP 7. Blurring the Other Rasterized Layer

STEP 8. Blending the Blurred Layers

STEP 9. Entering the Title

STEP 10. Adding Black Shadows to the Text

STEP 11. Making a Crosshair in the Image

STEP 12. Adding Text to the Image

STEP 13. Resizing and Positioning the Text

STEP 14. Drawing a Black Circle

STEP 15. Copying the Circle and Adding a Glow

STEP 16. Adding a Circle

STEP 17. Blurring the New Circle

STEP 18. Making a New White Layer

STEP 19. Changing the Image Color

STEP 20. Adjusting the Image Color

## STEP 1. Making a New Image with a Sky Blue Background

Choose File, New (Ctrl/Command+N) from the menu bar to open the New dialog box. Set the Width to 800 pixels and the Height to 600 pixels. Set the Resolution to 100 pixels/inch, and then click OK. Use the Color palette to set the foreground color to sky blue (R:51, G:196, B:244). Use the Paint Bucket tool or press Alt/Option+Del to fill the Background layer with sky blue.

## STEP 2. Entering Text

Choose the Horizontal Type tool from the toolbox. Open the Character palette by clicking the Toggle the Character and Paragraph palettes button on the Options bar. In the Character palette, choose the font settings shown here. Click in the image window, enter the text as shown, and click the Commit any current edits button on the Options bar.

## STEP 3. Sizing and Realigning the Text

Click in the text on the text layer, click the Center text button on the Options bar, and then click the Commit any current edits button. Choose the Move tool from the toolbox, and then drag the newly-aligned text into a centered position in the image window. Reselect the Horizontal Type tool. Select individual lines of the text and adjust its size and the spacing between words using the Character palette. Try to have the text span the image window, as shown here. Click the Commit any current edits button on the Options bar to finish.

## STEP 4. Rasterizing the Text

With the text layer still selected in the Layers palette, choose Layer, New, Layer via Copy (Ctrl/Command+J). Click the eye icon beside the original text layer to hide it. Right/Control-click on the text layer copy, and then click Rasterize Layer to convert the vector text to a bitmap image. Copy the rasterized layer by choosing Layer, New, Layer via Copy (Ctrl/Command+J). Click the eye icon beside the newest layer to hide it,

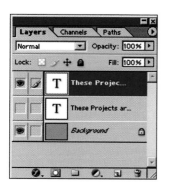

and then click the original rasterized layer below it. Next, Ctrl/Command-click on the original rasterized layer to make a selection in the shape of the letters. Choose Select, Modify, Expand from the menu bar to open the Expand Selection dialog box. Change the Expand By setting to 5, and then click OK.

## STEP 5. Blurring the Text Shapes

Choose Select, Feather from the menu bar to open the Feather Selection dialog box. Set the Feather Radius value to 5, and then click OK to soften the edges of the selection frame. Set the foreground color to black, and then use the Paint Bucket tool or press Alt/Option+Del to fill the modified selection with black.

## STEP 6. Blurring the Text Even More

Choose Select, Deselect (Ctrl/Command+D) from the menu bar to remove the selection marquee. Choose Filter, Blur, Gaussian Blur to open the Gaussian Blur dialog box. Change the Radius setting to 30, and then click OK to blur the layer contents.

## STEP 7. Blurring the Other Rasterized Layer

Click the layer thumbnail for the copy of the rasterized
layer (the top layer in the Layers palette) to both select and redisplay it. Choose Filter,
Blur, Gaussian Blur to open the Gaussian Blur dialog box. Change the Radius setting to
approximately 9.7, and then click OK to blur the layer contents.

## STEP 8. Blending the Blurred Layers

With the top layer (the copy of the raster-
ized layer) still selected, open the Opacity
slider on the Layers palette. Change the
slider setting to 34%, and then press
Enter/Return.

## STEP 9. Entering the Title

Click the Create a new layer button (Shift+Ctrl/Command+N) in the Layers palette to add a new layer named Layer 1. Use the Color palette to set the foreground color to sky blue

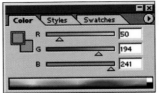

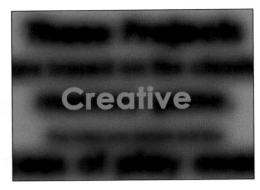

(R:51, G:196, B:244). Choose the Horizontal Type tool. Choose the font and font settings shown here in the Character palette. Click the Left align text button on the Options bar. Click in the image window, enter the text as shown, and click the Commit any current edits button on the Options bar.

## STEP 10. Adding Black Shadows to the Text

With the new text layer (the Creative layer) still selected in the Layers palette, click the Add a layer style button at the bottom of the palette. Click Outer Glow to open the Layer Style dialog box with the Outer Glow settings displayed. Adjust the dialog box settings as shown here, and then click OK to add a black and blurry shadow around the title text.

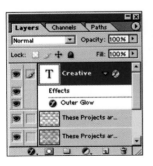

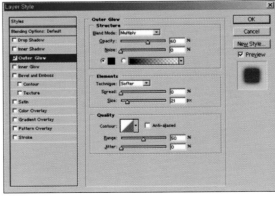

132     Photoshop 7 Type Effects

## STEP 11. Making a Crosshair in the Image

With the foreground color still set to the sky blue you specified earlier, click the Create a new layer button (Shift+Ctrl/Command+N) on the Layers palette to add a new layer named Layer 1. Choose View, Rulers (Ctrl/Command+R) from the menu bar to display the rulers. Drag down from the horizontal ruler at the top of the image window to add a guideline at approximately 8.5 cm. Drag right from the vertical ruler at the left to create a guideline at approximately 13.5 cm. Choose the Pencil tool from the toolbox. Use the Brush Preset picker from the Options bar to set the brush size to 1 pixel, if needed. Press and hold the Shift key, and then draw a line over each of the guidelines. Double-click the layer name, type "Line," and press Enter/Return to rename the layer. Choose View, Rulers (Ctrl/Command+R) and View, Show, Guides to hide the ruler and guides.

## STEP 12. Adding Text to the Image

Choose the Horizontal Type tool. Specify the font and font settings shown here in the Character palette. Click in the image window, type the letter "p" as shown, and click the Commit any current edits button on the Options bar.

## STEP 13. Resizing and Positioning the Text

Click the Create a new layer button (Shift+Ctrl/ Command+N) on the Layers palette to add a new layer named Layer 1.

Choose the Horizontal Type tool from the toolbox. Specify the font and font settings shown here in the Character palette. Click in the image window, type "hotoshop" as shown, and click the Commit any current edits button on the Options bar. Choose the Move tool from the toolbox. Click the p layer in the Layers palette, and then drag the p to the bottom-left corner of the layer. Click the hotoshop layer in the Layers palette, and then drag the hotoshop to the bottom-right corner of its layer, aligning the left side of the letter "h" to the vertical blue line you added in Step 11.

## STEP 14. Drawing a Black Circle

Click the Create a new layer button (Shift+Ctrl/ Command+N) on the Layers palette to make a new layer named Layer 1. Double-click the layer name, type "pointimage," and press Enter/Return to rename the layer. Set the fore-ground color to black by clicking the Default Foreground and Background Colors button on the toolbox. Choose the Elliptical Marquee tool from the toolbox, and press and hold the Shift key while you drag to draw a circular selection on the new layer. Use the Paint Bucket tool or press Alt/Option+Del to fill the circle with black as shown here.

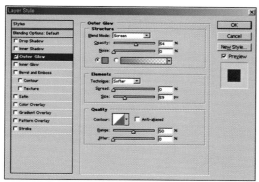
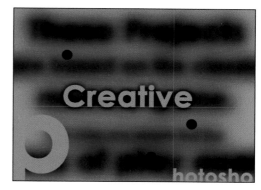

## STEP 15. Copying the Circle and Adding a Glow

With the original circle still selected, drag the selection marquee to another location on the layer as shown here, and press Alt/Option+Del to fill it. Repeat the process to add a third circle on the layer, positioned near the bottom. Choose Select, Deselect (Ctrl/Command+D) to remove the selection marquee. Click the Add a layer style button on the Layers palette, and then click Outer Glow. Choose the settings shown here in the Layer Style dialog box, and then click OK to add a sky blue glow around each of the black circles.

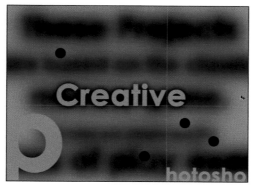

## STEP 16. Adding a Circle

Click the Create a new layer button (Shift+Ctrl/Command+N) on the Layers palette to add a new layer named Layer 1. Double-click the layer name, type "pointimage_2," and press Enter/Return to rename the layer. Choose the Elliptical Marquee tool from the toolbox, and press and hold the Shift key while you drag to draw a circular selection on the new layer. Use the Paint Bucket tool or press Alt/Option+Del to fill the circle with black as shown here. Choose Select, Deselect (Ctrl/Command+D) to remove the selection marquee.

## STEP 17. Blurring the New Circle

Choose Filter, Blur, Gaussian Blur from the menu bar to open the Gaussian Blur dialog box. Set the Radius to approximately 5.2, and then click OK to blur the circle you added to the newest layer. Blurring the circle adds depth to the image.

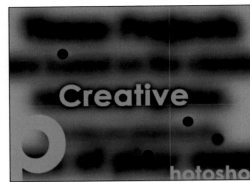

## STEP 18. Making a New White Layer

Try changing the color of the whole image to create an entirely different effect. Click the Create a new layer button (Shift+Ctrl/Command+N) on the Layers palette to add a new layer named Layer 1. Double-click the layer name, type "Shell," and press Enter/Return to rename the layer. Set the foreground color to white by clicking the Switch Foreground and Background Colors button on the toolbox. Use the Paint Bucket tool or press Alt/Option+Del to fill the new layer with white.

## STEP 19. Changing the Image Color

With the new Shell layer still selected in the Layers palette, click the Add a layer style button on the Layers palette, and then click Blending Options. In the Layer Style dialog box, choose Difference from the Blend Mode drop-down list, and change the Opacity setting to 85. Click OK to view the results.

## STEP 20. Adjusting the Image Color

Use an adjustment layer to tone down the image's color. Click the Create new fill or adjustment layer button at the bottom of the Layers palette, and then click Hue/Saturation. Adjust the settings in the Hue/Saturation dialog box as shown here, and then click OK.

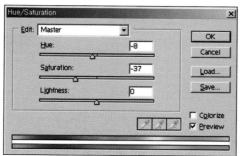

Typographic treatments punctuate this continuous flow of imagery which includes material from a variety of media.

Photoshop Effect Design PED

# Project 13: Simple Glass Type

In this project, you will learn how to use a variety of different effects to create texture, as well as how to blend pictures to create the imprint of a leaf. You'll use one of the styles provided with Photoshop to create a simple glass effect on the type.

Typographic treatments
punctuate this continuous
flow of imagery which
includes material from
a variety of
media.

Photoshop Effect Design PED

Simple
Glass Type

# Project 13: Simple Glass Type

Photoshop Effect Desi

## Total Steps

STEP 1.    Making a New Image

STEP 2.    Adding a Cloud Texture

STEP 3.    Selecting a Leaf Shape

STEP 4.    Drawing a Leaf Shape

STEP 5.    Making a Selection in the Shape of the Leaf

STEP 6.    Adjusting and Filling the Leaf Selection

STEP 7.    Moving the Selection Frame and Coloring it Black

STEP 8.    Deleting Leaf-Shaped Content

STEP 9.    Coloring a Leaf Shape

STEP 10.  Naming the Leaf Layer

STEP 11.  Importing a Source Image into the Leaf

STEP 12.  Blurring the Pasted Image

STEP 13.  Blending the Leaf Image

STEP 14.  Applying the Soft Light Blend Mode

STEP 15.  Entering Text and Adjusting Its Size

STEP 16.  Typing in "@" and Adjusting Its Size

STEP 17.  Applying a Layer Style to the @ Layer

STEP 18.  Modifying the Shape of the Applied Style

STEP 19.  Applying a Shadow to the Text

STEP 20.  Completing the Image

## STEP 1. Making a New Image

Choose File, New (Ctrl/Command+N) from the menu bar to open the New dialog box. Set the Width to 600 pixels and the Height to 600 pixels. Also set the Resolution to 100 pixels/inch, and then click OK.

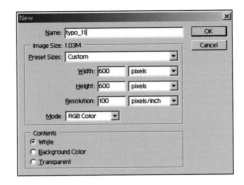

## STEP 2. Adding a Cloud Texture

Click the Default Foreground and Background Colors button on the toolbox to reset the foreground color to black and the background color to white. Then choose Filter, Render, Difference Clouds from the menu bar. Press Ctrl/Command+F to reapply the filter until the texture has the desired appearance. Choose Filter, Render, Lighting Effects to open the Lighting Effects dialog box. Adjust the handles in the Preview area as shown here to

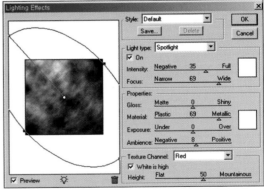

redirect the "light" to shine from the upper-left corner and to make the "light" more diffuse. Choose Red from the Texture Channel drop-down list, and then click OK.

## STEP 3. Selecting a Leaf Shape

Choose the Custom Shape tool from the toolbox. Click the Click to open Custom Shape picker button on the Options bar. Click the palette menu button in the upper-right corner of the palette that appears, and then click Nature. Click OK or Append as needed in the message box that appears to replace or append the shapes. Scroll down, if needed, click the Leaf 5 (Maple leaf) shape, and then press Enter/Return.

## STEP 4. Drawing a Leaf Shape

Click the Shape Layers button on the Options bar, if needed. Also click the Switch Foreground and Background Colors button on the toolbox to change the foreground color to white and the background color to black. Drag the mouse in the image window to create the leaf shape. Choose Edit, Free Transform (Ctrl/Command+T) from the menu bar. Use the handles that appear to adjust the rotation and size of the leaf, and then press Enter/Return.

### STEP 5. Making a Selection in the Shape of the Leaf

Click the Create a new layer button (Shift+Ctrl/Command+N) in the Layers palette to make a new layer named Layer 1. Double-click on the Layer 1 layer name, type "engraving," and then press Enter/Return to rename the layer. Ctrl/Command-click the Shape 1 (leaf) layer to create a selection marquee in the shape of the leaf.

### STEP 6. Adjusting and Filling the Leaf Selection

Choose Select, Feather from the menu bar to open the Feather Selection dialog box. Set the Feather Radius to 5, and then click OK. Press the ↓ and → keys twice each to move the marquee slightly down and to the right. Set the foreground color to white, if needed, and then use the Paint Bucket tool or press Alt/Option+Del to fill the selection with white.

## STEP 7. Moving the Selection Frame and Coloring it Black

Press the ↑ and ← keys four times each to move the selection marquee slightly up and to the left. Set the foreground color to black, and then use the Paint Bucket tool or press Alt/Option+Del to fill the selection with black.

## STEP 8. Deleting Leaf-Shaped Content

With the engraving layer still selected in the Layers palette, Ctrl/Command-click the Shape 1 (leaf) layer to reselect the original leaf selection. Click the eye icon next to the Shape 1 layer to hide it. Press the Del key to remove the black fill from the selection. Choose Select, Deselect (Ctrl/Command+D) to see that the Background layer now appears to have a leaf imprint.

## STEP 9. Coloring a Leaf Shape

Click the Create a new layer button (Shift+Ctrl/Command+N) in the Layers palette to make a new layer named Layer 1. With the new layer selected, Ctrl/Command-click the Shape 1 layer to make a leaf-shaped selection on the new layer. Double-click the Set foreground color button on the toolbox, use the Color Picker dialog box to choose the foreground color shown here, and then click OK. Use the Paint Bucket tool or press Alt/Option+Del to fill the selection with the new foreground color. Leave the selection marquee in place.

### STEP 10. Naming the Leaf Layer

Double-click on the Layer 1 layer name, type "leaf," and then press Enter/Return to rename the layer.

## STEP 11. Importing a Source Image into the Leaf

Choose File, Open (Ctrl/Command+O) and open the Book\Sources\gogh-01.jpg file from the supplementary CD-ROM. You will fill the leaf's interior with this image. With gogh_01.jpg as the active image, choose Select, All (Ctrl/Command+A) from the menu bar to select the entire image. Press Ctrl/Command+C to copy the selection, and then choose File, Close (Ctrl/Command+W) to close the file. Back in the project file, choose Edit, Paste

Into (Shift+Ctrl/Command+V) to paste the copied image file into the selection—the interior of the leaf. Double-click on the Layer 1 layer name, type "image1," and then press Enter/Return to rename the layer.

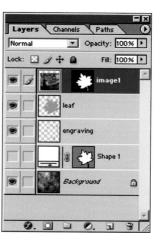

## STEP 12. Blurring the Pasted Image

Click on the layer that holds the newly pasted image. Select the Move tool in the toolbox, if needed. Choose Edit, Free Transform (Ctrl/Command+T) from the menu bar. Use the handles that appear to adjust the size of and position of the pasted image, so it completely fills the leaf, and then press Enter/Return. Choose Filter, Blur, Gaussian Blur from the menu bar to open the Gaussian Blur dialog box. Set the Radius to 5, and then click OK to blur the pasted image.

### STEP 13. Blending the Leaf Image

With the image1 layer selected in the Layers palette, click the Add a layer style button, and then click Blending Options. In the Layer Style dialog box, choose Soft Light from the Blend Mode drop-down list, and then click OK. Click the leaf layer, and then use the Opacity slider on the Layers palette to reduce its opacity to approximately 15%, so that it blends in naturally with the background texture.

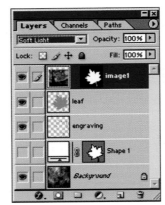

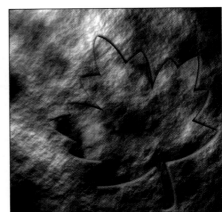

### STEP 14. Applying the Soft Light Blend Mode

Click the image1 layer in the Layers palette to select the layer, and then choose Layer, New, Layer via copy (Ctrl/Command+J) to create a copy of the layer. Double-click on the copied layer's name, type "image2," and then press Enter/Return to rename the layer. Click the Add a layer style button, and then click Blending Options. In the Layer Style dialog box, choose Soft Light from the Blend Mode drop-down list, and then click OK.

## STEP 15. Entering Text and Adjusting Its Size

Click the Set Default Foreground and Background colors button on the toolbox to reset the foreground color to black. Choose the Horizontal Type tool from the toolbox, and then click the Toggle the Character and Paragraph palettes button on the Options bar to open the Character palette, if needed. Specify the font and font settings shown here in the Character palette. Click in the image window, enter the text as shown, and click the Commit any current edits button on the Options bar. Also use the Character palette to adjust the size and color of selected words as shown. Click the Commit any current edits button on the Options bar after you make the final changes.

## STEP 16. Typing "@" and Adjusting Its Size

Click the image2 layer in the Layers palette to select that layer. Specify the font and font settings shown here in the Character palette. Click in the image window, type "@," and click the Commit any current edits button on the Options bar. Choose Edit, Free Transform (Ctrl/Command+T) from the menu bar, use the handles that appear to adjust the size and position of the @ symbol, and then press Enter/Return.

## STEP 17. Applying a Layer Style to the @ Layer

Drag the @ layer above the other layer in the Layers palette. With the @ layer selected, display the Styles palette by choosing Window, Styles from the menu bar. Click the Blue Glass style (the fifth style on the top row, by default) to apply it to the @ symbol. Choose Window, Color to redisplay the Color palette.

## STEP 18. Modifying the Shape of the Applied Style

If you examine the @ layer in the Layers palette, you can see that the Blue Glass style you applied in the last step actually was a shortcut for applying four different layer effects. You can adjust any of these effects. In this case, double-click the Bevel and Emboss effect below the layer name to open the Layer Style dialog box. Adjust the dialog box settings as shown here to emphasize the 3-D shape of the text, and then click OK.

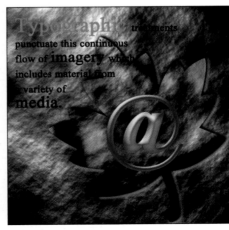

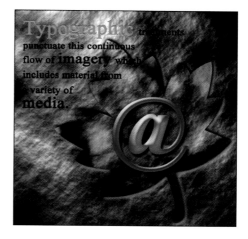

## STEP 19. Applying a Shadow to the Text

With the @ layer still selected in the Layers palette, click the Add a layer style button, and then click Drop Shadow. Adjust the dialog box settings as shown here, and then click OK.

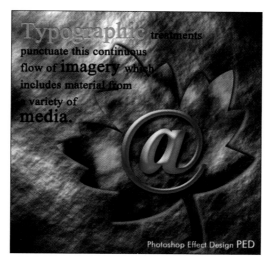

## STEP 20. Completing the Image

Click the Create a new layer button (Shift+Ctrl/Command+N) on the Layers palette to make a new layer named Layer 1. Set the foreground color to white, and then choose the Horizontal Type tool from the toolbox. Specify the font and font settings shown here in the Character palette. (Choose a similar sans serif font if Futura is not available.) Click in the image window, enter the text as shown, and click the Commit any current edits button on the Options bar.

# Project 14: Fire Shock

Here, use the Wind filter to create a fiery effect around text.
Then, use the Lens Flare filter along with other effects to
develop an attractive stone texture. An image like this makes
a fantastic focal point for a Web site, animation, or printed
piece.

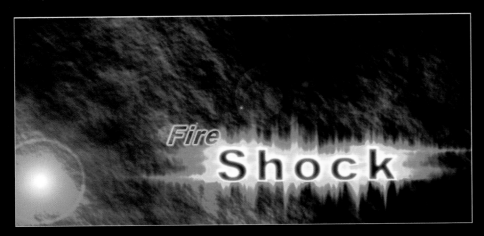

**Fire Shock**

# Project 14: Fire Shock

## Total Steps

STEP 1.  Making a New Image
STEP 2.  Entering White Text on a Black Background
STEP 3.  Applying the Wind Filter
STEP 4.  Applying Wind From the Other Side
STEP 5.  Rotating the Text
STEP 6.  Applying Wind to the Top and Bottom of the Text
STEP 7.  Rotating the Text to Its Original Orientation
STEP 8.  Establishing Fiery Color
STEP 9.  Changing the Text Color on the Text Layer

STEP 10.  Adding a Blur to the Text
STEP 11.  Adding a Glow to the Text
STEP 12.  Adding a Cloud Texture
STEP 13.  Applying Directional Light to the Cloud Texture
STEP 14.  Blending the Cloud Layer with a Red Layer
STEP 15.  Blending the Background and the Text
STEP 16.  Entering More Text
STEP 17.  Illuminating the Edges
STEP 18.  Making a Halo of Light Using the Lens Flare Filter
STEP 19.  Blending the Halo of Light
STEP 20.  Cropping the Image

## STEP 1. Making a New Image

Choose File, New (Ctrl/Command+N) from the menu bar to open the New dialog box. Set both the Width and Height to 800 pixels, and then set the Resolution to 150 pixels/inch. Click OK.

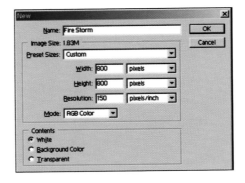

## STEP 2. Entering White Text on a Black Background

After setting the foreground color to black, use the Paint Bucket tool or press Alt/Option+Del to fill the Background layer with black. Click the Switch Default Foreground and Background Colors button on the toolbox to set the foreground color to white. Choose the Horizontal Type tool from the toolbox, and then click the Toggle the Character and Paragraph palettes button on the Options bar to open the Character palette, if needed. Specify the font and font settings shown here in the Character palette. Click in the image window, enter the text as shown, and then click the Commit any current edits button on the Options bar. Choose Layer, New, Layer via Copy (Ctrl/Command+J) to copy the new text layer, and then click the original Shock layer in the Layers palette to reselect the layer.

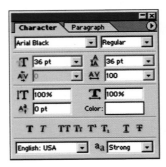

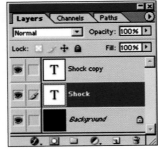

## STEP 3. Applying the Wind Filter

Click the palette menu button in the upper-right corner of the Layers palette, and then click Merge Down to merge the Shock layer and the black Background layer. Click on the eye icon

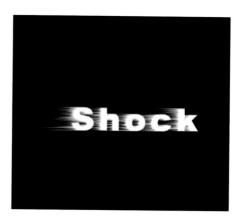

beside the Shock copy layer to hide it. Choose Filter, Stylize, Wind from the menu bar. Verify that the Wind dialog box has the settings shown here, and then click OK. The text looks as if it is being blown across the page by wind from the right. To make the effect stronger, press Ctrl/Command+F twice to apply the Wind filter two more times.

## STEP 4. Applying Wind from the Other Side

Choose Filter, Stylize, Wind from the menu bar again. In the Wind dialog box, click the From the Left option button, and then click OK. This time, the wind appears to come from the left to blow the text. Press Ctrl/Command+F twice to apply the Wind filter command two more times. Strong rays of light now appear to be crossing the text.

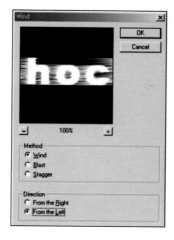

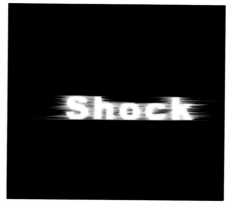

## STEP 5. Rotating the Text

You now want to create the same kind of rays of light from the top and bottom of the text. Because the Wind command can only be applied in the horizontal direction, rotate the image 90° before applying the filter. Choose Image, Rotate Canvas, 90° CW to rotate the image 90° clockwise.

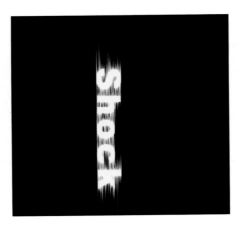

## STEP 6. Applying Wind to the Top and Bottom of the Text

Choose Filter, Stylize, Wind from the menu bar. In the Wind dialog box, click the From the Right option button, and then click OK. Press Ctrl/Command+F to apply the filter one more time. Choose Filter, Stylize, Wind from the menu bar. In the Wind dialog box, click the From the Left option button, and then click OK. Press Ctrl/Command+F to apply the command one more time.

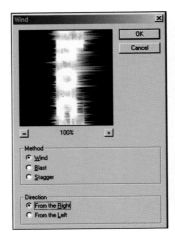

## STEP 7. Rotating the Text to Its Original Orientation

Choose Image, Rotate Canvas, 90° CCW from the menu bar to rotate the image 90° counter-clockwise. Rays of light now shoot up and down from the text. Choose Filter, Blur, Gaussian Blur. In the Gaussian Blur dialog box, set the Radius to approximately 1.6 pixels, and then click OK to soften the rays of light.

## STEP 8. Establishing Fiery Color

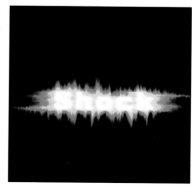

Click the Default Foreground and Background Colors button on the toolbox to reset the foreground color to black. Choose Image, Adjustments, Gradient Map from the menu bar to open the Gradient Map dialog box. Click the box under Gradient Used for Grayscale Mapping to open the Gradient Editor dialog box. Click the first gradient preset in the Presets area, and then create two more color stops at the bottom of the gradient preview to include additional gradient colors. To set up a stop, click the bottom of the gradient preview, and then use the Color box at the bottom of the dialog box to choose the color for that stop. Click on the bottom of the gradient graph and double-click on the color stop to set up the gradient color or drag the color stop from side to side to delete. Click OK to close the Gradient Editor dialog box, and then click OK again to apply the gradient.

## STEP 9. Changing the Text Color on the Text Layer

Click the Shock copy layer in the Layers palette to select and redisplay that layer. In the Character palette, change the Color setting to a dark brown.

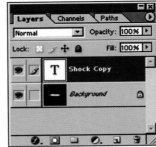

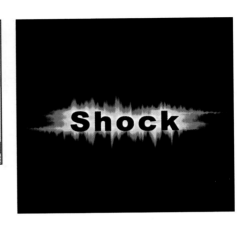

## STEP 10. Adding a Blur to the Text

With the Shock copy layer still selected in the Layers palette, click the Add a layer style button at the bottom of the Layers palette, and then click Inner Shadow. Adjust the settings in the Layer Style dialog box as shown here, and then click OK. This will create a blurry white shadow on the inside of the brown text.

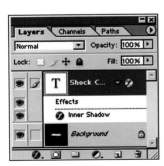

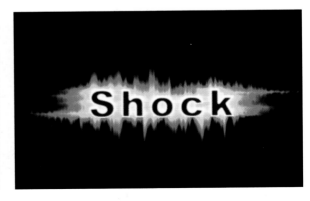

## STEP 11. Adding a Glow to the Text

With the Shock copy layer still selected, click the Add a layer style button at the bottom of the Layers palette, and then click Inner Glow. Adjust the settings in the Layer Style dialog box as shown here, and then click OK. This will apply a red inner glow to the text.

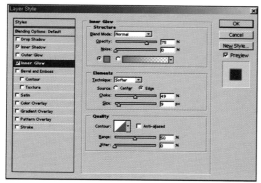

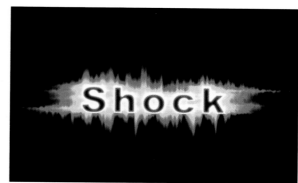

## STEP 12. Adding a Cloud Texture

Double-click on the Background in the Layers palette, and then click OK in the New Layer dialog box to convert the Background layer into a regular layer named Layer 0. Click the Create a new layer button (Shift+Ctrl/Command+N) in the Layers palette to add a new layer named Layer 1. Double-click on the new layer's name, type "Cloud," and then press Enter/Return to rename the layer. Drag the Cloud layer to the bottom of the Layers palette, and then click the eye icon beside

each layer above the Cloud layer to hide those layers. Click the Default Foreground and Background Colors button in the toolbar to make the foreground color black and the background color white. Choose Filter, Render, Clouds from the menu bar to add a cloud texture to the Cloud layer.

**STEP 13.** Applying Directional Light to the Cloud Texture

Choose Filter, Render, Lighting Effects from the menu bar to open the Lighting Effects dialog box. Adjust the handles in the Preview area as shown here to redirect the "light" to shine from the upper-left corner and to make the "light" more diffuse. Choose Red from the Texture Channel drop-down list, and then click OK.

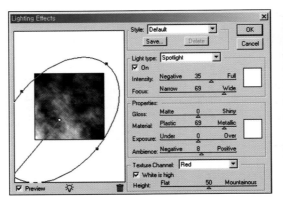

**STEP 14.** Blending the Cloud Layer with a Red Layer

Click the Create a new layer button (Shift+Ctrl/Command+N) on the Layers palette to make a new layer named Layer 1. Drag Layer 1 below the Cloud layer in the Layers palette. After setting the foreground color to red, use the Paint Bucket tool or press Alt/Option+Del to fill the new layer with red. Click on the Cloud layer in the Layers palette to select it. Click the Add a layer style button, and then click Blending Options. In the Layer Style dialog box, choose Darken from the Blend Mode drop-down list, and then click OK to blend the cloud image with the red background.

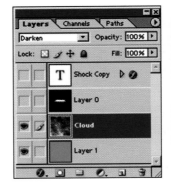

## STEP 15. Blending the Background and the Text

Click the box for the eye icon beside each hidden layer in the Layers palette to redisplay each of the layers. Click Layer 0 in the Layers palette to select that layer. Click the Add a layer style button, and then click Blending Options. In the Layer Style dialog box, choose Screen from the Blend Mode drop-down list, and then click OK to remove the black background from around the text and blend the fiery text into the red background.

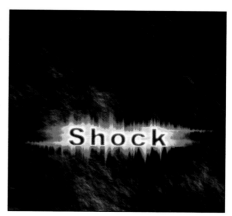

## STEP 16. Entering More Text

Click the Shock copy layer in the Layers palette to select that layer, and then click the empty box next to the Layer 0 layer so that a chain link appears, indicating that the layers are now linked. Choose the Move tool from the toolbox, and drag the fiery text to the desired location on the Shock Copy layer. The linked Layer 0 content also will move. Choose the Horizontal Type tool from the toolbox, and then drag on the image to create a box to hold the added text. Specify the font and font settings shown here in the Character palette. Type "Fire," and then click the Commit any current edits button on the Options bar.

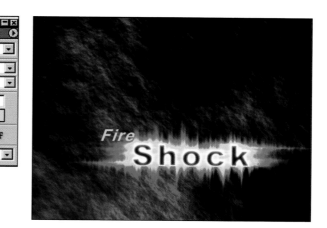

## STEP 17. Illuminating the Edges

With the Fire layer still selected in the Layers palette, click the Add a layer style button at the bottom of the palette, and then click Outer Glow. Change the settings in the Layer Style dialog box, as shown here, and then click OK. Use the Fill slider on the Layers palette to

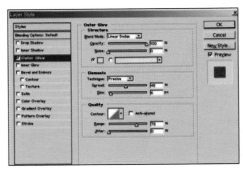
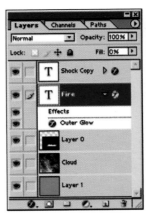
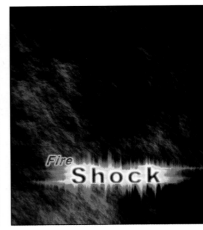

change the fill for the Fire layer to 0%. The text will become transparent, but the glow effect around remains.

## STEP 18. Making a Halo of Light Using the Lens Flare Filter

Click the Create a new layer button (Shift+Ctrl/Command+N) in the Layers palette to make a new layer named Layer 2. Double-click on the new layer's name, type "Flare," and then press Enter/Return to rename the layer. Drag the Flare

layer to the top of the Layers palette, if needed. Click the Default Foreground and Background Colors button on the toolbox to reset the foreground color to black, and then use the Paint Bucket tool or press Alt/Option+Del to fill the new layer with black. Choose Filter, Render, Lens Flare from the menu bar. In the Lens Flare dialog box, click near the lower-left corner of the Flare Center box to position the halo of light as shown here. Click OK. A halo of light resembling an optical lens effect appears on the black layer.

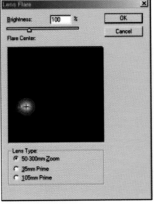
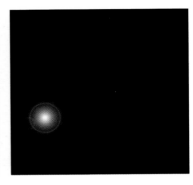

## STEP 19. Blending the Halo of Light

With the Flare layer still selected in the Layers palette, click the Add a layer style button at the bottom of the palette, and then click Blending Options. Choose Linear Dodge from the Blend Mode drop-down list, and then click OK. The layer's black fill will become transparent, and the halo of light will blend naturally with the other layers. If desired, use the Move tool to position the halo of light on the Flare layer in the desired location.

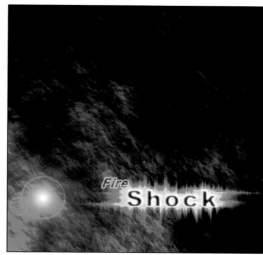

## STEP 20. Cropping the Image

Choose the Rectangular Marquee tool from the toolbox. Select the desired portion of the image, and then choose Image, Crop from the menu bar to remove areas outside the selection.

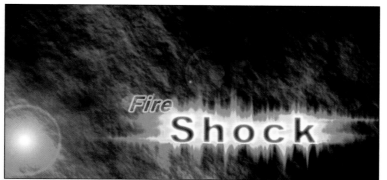

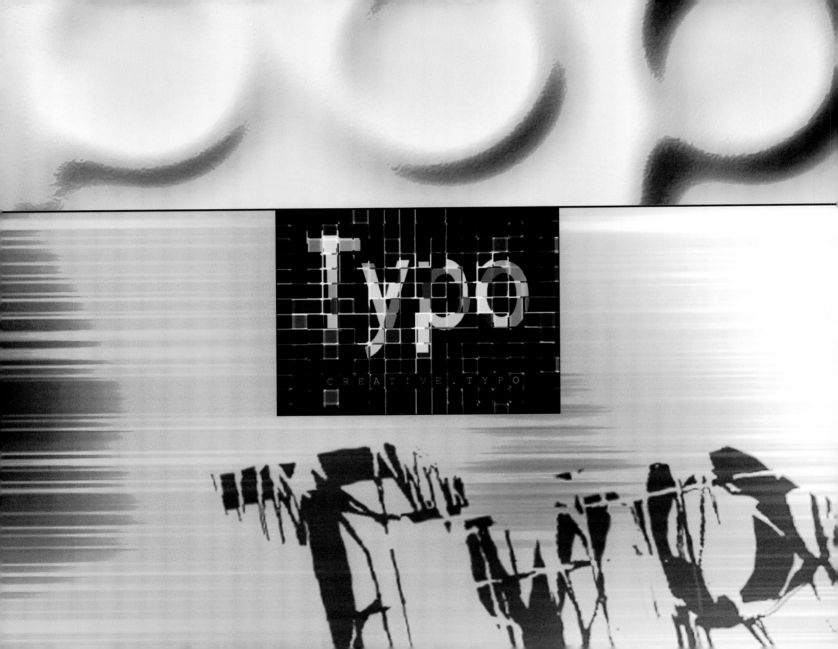

# Project 15: Glass Block Refraction

Use the Displace filter in this project to create words that appear to have been created from glass blocks. See how to use various layer blending methods to create transparent glass block effects.

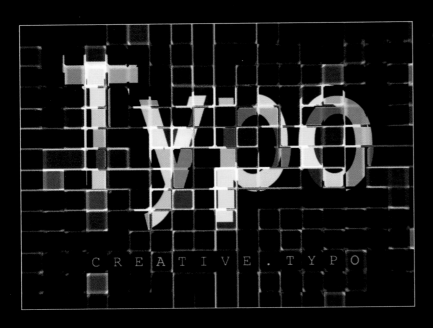

## Glass Block Refraction

# Project 15: Glass Block Refraction

## Total Steps

STEP 1. Making a New Image with a Black Background

STEP 2. Applying Noise to the Image

STEP 3. Clumping the Noise Speckles

STEP 4. Creating a Tiled Appearance

STEP 5. Outlining the Blocks

STEP 6. Brightening the Outlines

STEP 7. Saving a Displace Map Image

STEP 8. Entering Text on a Black Background

STEP 9. Blending the Text with the Black Background

STEP 10. Applying the Displace Map to Layer 1

STEP 11. Varying the Brightness of the Letters

STEP 12. Displaying the Block Outlines

STEP 13. Making the Block Edges Appear More Natural

STEP 14. Copying the Add Light Layer

STEP 15. Darkening the Add Color Layer

STEP 16. Making the Add Color Layer Green

STEP 17. Blending the Block Color with the Text

STEP 18. Dimming the Text

STEP 19. Emphasizing the Block Edges

STEP 20. Entering the Subtitle

## STEP 1. Making a New Image with a Black Background

Choose File, New (Ctrl/Command+N) from the menu bar to open the New dialog box. Set the Width to 640 pixels and the Height to 480 pixels. Set the Resolution to 72 pixels/inch, and then click OK. Click the Default Foreground and Background Colors button on the toolbox to make the foreground color black and the background color white. Use the Paint Bucket tool or press Alt/Option+Del to fill the Background layer with black.

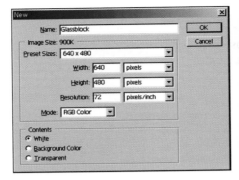

## STEP 2. Applying Noise to the Image

Choose Filter, Noise, Add Noise from the menu bar. In the Add Noise dialog box, set the Amount value to 400, and then click OK. Black and white noise fills the Background layer.

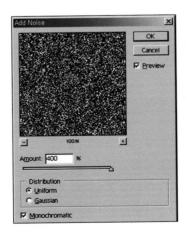

## STEP 3. Clumping the Noise Speckles

Choose Filter, Noise, Median from the menu bar. In the Median dialog box, set the Radius value to 3, and then click OK. The noise speckles clump together on the Background layer.

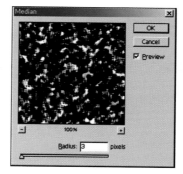

## STEP 4. Creating a Tiled Appearance

Choose Filter, Pixelate, Mosaic from the menu bar. In the Mosaic dialog box, set the Cell Size value to 35, and then click OK. The image will be converted into square tiles of 35 pixels, even though they may be so dark that you can't initially see them. To lighten the tiles and make them visible, choose Image, Adjustments, Auto Levels (Shift+Ctrl/Command+L).

## STEP 5. Outlining the Blocks

Now add lines between the glass blocks. Drag the Background layer onto the Create a new layer button on the Layers palette to copy the layer. Click the eye icon beside the copied layer (Background copy) to hide it. Click the Background layer in the Layers palette, and then choose Filter, Stylize, Glowing Edges from the menu bar. Choose the settings shown here in the Glowing Edges dialog box, and then click OK. Bright edges appear around the blocks.

## STEP 6. Brightening the Outlines

Choose Image, Adjustments, Levels (Ctrl/Command+L) from the menu bar to open the Levels dialog box. Drag the far right Input Levels slider to the left until the Input Levels settings match those shown here, and then click OK. The white outlines become brighter.

## STEP 7. Saving a Displace Map Image

In the Layers palette, click the Background copy
layer to both select and redisplay it. Click the
Add a layer style button at the bottom of the
Layers palette, and then click Blending Options.
In the Layer Style dialog box, choose Lighten
from the Blend Mode drop-down list, and then
click OK. Use File, Save (Ctrl/Command+S) to
save the current file as gblock_disp.psd. You will use this file as
the Displace map. For your convenience, the file is included on
the supplementary CD-ROM (Book\Sources\gblock_disp.psd).

## STEP 8. Entering Text on a Black Background

Click the Create a new layer button (Shift+Ctrl/Command+N) on the Layers palette to make a new
layer named Layer 1. Use the Paint Bucket tool or press Alt/Option+Del to fill the new layer with
the current foreground color, black. Choose the Horizontal Type tool from the toolbox, and then
click the Toggle the Character and Paragraph palettes button on the Options bar to open the
Character palette, if needed. Choose the font and font settings shown here

in the Character
palette. Click in the
image window,
enter the text as
shown, and then
click the Commit any
current edits button
on the Options bar.

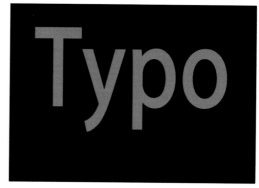

## STEP 9. Blending the Text with the Black Background

With the new text layer selected in the Layers palette, click the palette menu button in the upper-right corner of the Layers palette, and then click Merge Down to merge the text layer contents onto Layer 1.

## STEP 10. Applying the Displace Map to Layer 1

Choose Filter, Distort, Displace from the menu bar to open the Displace dialog box. Click the Tile option button under Displacement Map, and then click OK. In the Choose a displacement map dialog box, select the gblock_disp.psd file, and then click Open. (You can choose Book\Sources\gblock_disp.psd from the supplementary CD-ROM if you did not save your own file earlier.) The text cracks in the pattern of the glass blocks.

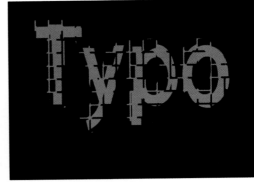

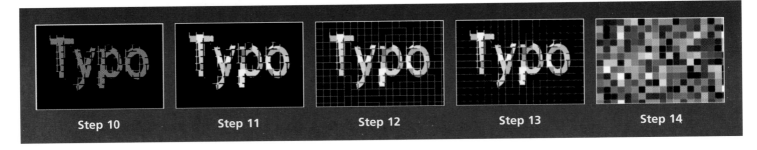

Step 10    Step 11    Step 12    Step 13    Step 14

## STEP 11. Varying the Brightness of the Letters

Click the Background copy layer in the Layers palette, and then choose Layer, New, Layer via Copy (Ctrl/Command+J) to copy the layer. Drag the copied layer to the top of the Layers palette. Double-click the layer's name, type "Add Light," and then press Enter/Return to rename the layer. Click the Add a layer style button at the bottom of the Layers palette, and then click Blending Options. In the Layer Style dialog box, choose

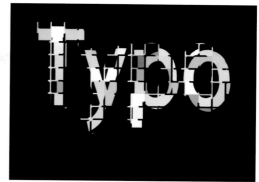

Color Dodge from the Blend Mode drop-down list, and then click OK. The gray blocks blend with the gold text to vary the color.

## STEP 12. Displaying the Block Outlines

Click the Background layer in the Layers palette, and then choose Layer, New, Layer via Copy (Ctrl/Command+J) to copy the layer. Drag the copied layer to the top of the Layers palette. Double-click the layer's name, type "Edge," and then press Enter/Return to rename the layer. Click the Add a layer style button at the bottom of the Layers palette, and then click Blending Options. In the Layer Style dialog box, choose Difference from the Blend Mode drop-down list, change the Fill Opacity setting to 44%, and then click OK.

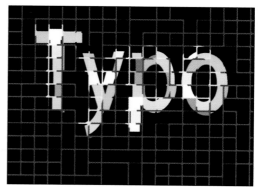

## STEP 13. Making the Block Edges Appear More Natural

Choose Filter, Blur, Radial Blur from the menu bar to open the Radial Blur dialog box. Set the Amount to 10 and the Blur Method to Zoom, and then click OK.

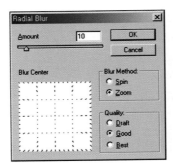

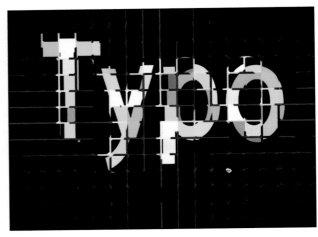

## STEP 14. Copying the Add Light Layer

Click the Add Light in the Layers palette, and then choose Layer, New, Layer via Copy (Ctrl/Command+J) to copy the layer. Double-click the layer's name, type "Add Color," and then press Enter/Return to rename the layer.

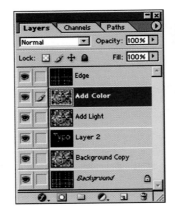

## STEP 15. Darkening the Add Color Layer

Click the eye icon beside all layers except the Add Color layer to hide those layers. With the Add Color layer still selected in the Layers palette, choose Image, Adjustments, Curves from the menu bar. Click near the center of the diagonal line in the graph, drag it and the top handle to create the curve shown here, and then click OK.

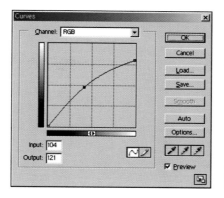

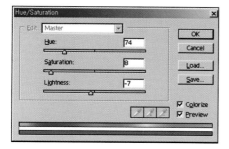

## STEP 16. Making the Add Color Layer Green

Choose Image, Adjustments, Hue/Saturation (Ctrl/Command+U) from the menu bar to open the Hue/Saturation dialog box. Click the Colorize check box to check it, and then drag the sliders to choose the settings shown here. Click OK to apply the subtle green tint shown here.

## STEP 17. Blending the Block Color with the Text

With the Add Color layer still selected in the Layers palette, click the Add a layer style button at the bottom of the Layers palette, and then click Blending Options. In the Layer Style dialog box, choose Linear Light from the Blend Mode drop-down list, and then click OK. Click the eye icon box beside each of the other layers to redisplay them. At this point, the text appears too bright.

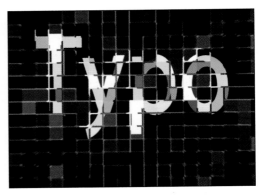

## STEP 18. Dimming the Text

Click the Add Light layer in the Layers palette to select it. Use the Fill slider on the Layers palette to reduce the Fill setting to 32%. The text now appears more natural.

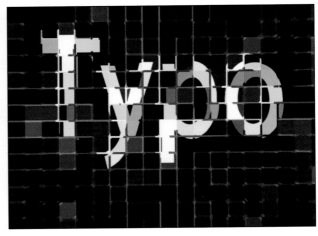

## STEP 19. Emphasizing the Block Edges

Click the Edge layer in the Layers palette, and then choose Layer, New, Layer via Copy (Ctrl/Command+J) from the menu bar to copy the layer. Double-click the layer's name, type "Edge Color," and then press Enter/Return to rename the layer.

Click the Add a layer style button at the bottom of the Layers palette, and then click Blending Options. In the Layer Style dialog box, choose Color Dodge from the Blend Mode drop-down list, change the Fill Opacity setting to 66%, and then click OK. The lines between the glass blocks brighten.

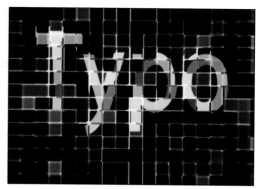

## STEP 20. Entering the Subtitle

Choose the Horizontal Type tool from the toolbox. Choose the font and font settings shown here in the Character palette.

Click in the image window, enter the subtitle text as shown, and then click the Commit any current edits button on the Options bar.

The letters of the subtitle are each arranged precisely on a glass block.

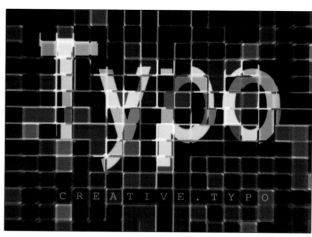

Photoshop Effect Design  PED

# Project 16: An Ant Hole

In this project, use Photoshop 7.0's improved brush tools to create an image that appears to have been drawn by hand. Also use the Warp Text feature to distort text to create a fun and amusing image.

An Ant Hole

Photoshop Effect Design PED

# Project 16: An Ant Hole

Photoshop Effect Design PED

## Total Steps

STEP 1.   Drawing Lines with a Rough Brush
STEP 2.   Curving the Lines into a Circle
STEP 3.   Typing in "Photoshop"
STEP 4.   Warping the Text
STEP 5.   Warping the Copied Text
STEP 6.   Adding a Sandy Texture to the Text
STEP 7.   Completing the Sandy Text
STEP 8.   Copying the Sandy Text Layer
STEP 9.   Blurring the Black Sandy Text
STEP 10.  Rotating the Shadow
STEP 11.  Inserting the Ant Image
STEP 12.  Removing the Ant's Messy Edges

STEP 13.  Coloring the Ant Red
STEP 14.  Adding a New Layer
STEP 15.  Filling the New Layer
STEP 16.  Adding a Sandy Texture
STEP 17.  Completing the Sandy Texture
STEP 18.  Adjusting the Brightness and Contrast of the Sand Texture
STEP 19.  Removing a Portion of the Sand Texture
STEP 20.  Making the Ant's Shadow
STEP 21.  Slanting the Ant's Shadow
STEP 22.  Completing the Ant's Shadow
STEP 23.  Entering the Text to Complete the Image

## STEP 1. Drawing Lines with a Rough Brush

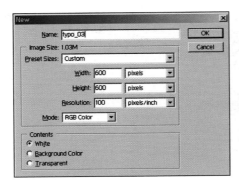

Choose File, New (Ctrl/Command+N) from the menu bar to open the New dialog box. Set both the Width and Height to 600 pixels, and then set the Resolution to 100 pixels/inch. Click OK. Choose the Brush Tool from the toolbox. Click the Click to open the Brush Preset picker button on the Options bar. Click the palette menu button in the palette that appears, and then click Dry Media Brushes. Click OK to replace the brushes in the palette with the dry media brushes. Choose the brush of your choice, and press Enter/Return to close the palette. Click the Default Foreground and Background Colors button on the toolbox. Choosing various rough, charcoal-like brushes using the Brush Preset picker, draw in horizontal lines as shown here. Press and hold the Shift key while dragging to draw straight lines.

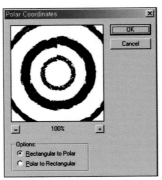

## STEP 2. Curving the Lines into a Circle

Choose Filter, Distort, Polar Coordinates from the menu bar, and then click OK in the Polar Coordinates dialog box to bend the lines into a circle with concentric rings. Double-click the Background layer's name, type "Layer 1" as the new layer name, and then press Enter/Return to rename the layer and convert it to a regular layer.

## STEP 3. Typing in "Photoshop"

Use the Color palette to set the foreground color to red. Choose the Horizontal Type tool from the toolbox, and then click the Toggle the Character and Paragraph palettes

button on the Options bar to open the Character palette, if needed. Choose a sans serif font such as Century Gothic, choose the Bold font style, and return settings that add extra space between lines and letters back to (Auto) or 0 in the Character palette. Click in the image window, enter the text as shown, and then click the Commit any current edits button on the Options bar. Choose Edit, Free Transform (Ctrl/Command+T), drag the handles that appear to size the text as shown here, and then press Enter/Return. Choose Layer, New, Layer via Copy (Ctrl/Command+J) to copy the text layer, creating a layer named Photoshop copy. Click the eye icon beside the Photoshop copy layer to hide the layer.

## STEP 4. Warping the Text

Bend the text to make it look as if it is being sucked into the center of the circle. Click the Photoshop text layer in the Layers palette to select that layer. With the Horizontal Type tool still selected in the toolbox, click the Create warped text button on the Options bar. Choose Arc from the Style drop-down list at the top of the Warp Text dialog box. Drag the sliders to choose the settings shown here, and then click OK to warp the text. Choose Edit, Free Transform (Ctrl/Command+T), resize and reposition the text as shown here, and then press Enter/Return.

## STEP 5. Warping the Copied Text

Click the Photoshop copy layer in the Layers palette to both select and redisplay the layer. With the Horizontal Type tool still selected in the toolbox, click the Create warped text button on the Options bar. Choose Flag from the Style drop-down list at the top of the Warp Text dialog box. Drag the sliders to choose the settings shown here, and then click OK to warp the text. Choose Edit, Free Transform (Ctrl/Command+T). Resize, rotate, and position the text as shown here, and then press Enter/Return.

## STEP 6. Adding a Sandy Texture to the Text

With the Photoshop copy layer still selected in the Layers palette, set the foreground color to red and the background color to white, if needed. Choose Filter, Distort, Glass from the menu bar. Click OK in the message box that asks whether to rasterize the type. Specify the settings shown here in the Glass dialog box, and then click OK.

## STEP 7. Completing the Sandy Text

Choose Filter, Brush Strokes, Spatter to open the Spatter dialog box. Choose the settings shown here, and then click OK. To delete the white areas from the text, choose the Magic Wand tool from the toolbox. Click the red text on the Photoshop copy layer, and then choose Select,

Similar from the menu bar to select colors similar to the color you initially selected. Invert the selection by choosing Select, Inverse (Shift+Ctrl/Command+I). Then press the Del key to remove the pixels in the selection. Choose Select, Deselect (Ctrl/Command+D) to remove the selection marquee.

## STEP 8. Copying the Sandy Text Layer

Click the Create a new layer button (Shift+Ctrl/Command+N) on the Layers palette to add a new layer named Layer 2. Ctrl/Command-click the Photoshop copy (sandy text) layer to make a selection in the shape of the sandy text on Layer 2. Click the Default Foreground and Background Colors button on the toolbox to reset the foreground color to black, and then use the Paint Bucket tool or press Alt/Option+Del to fill the selection on the new layer. Choose Select, Deselect (Ctrl/Command+D) to remove the selection marquee. Choose the Move tool from the toolbox, and drag the layer contents slightly to the left, as shown here.

## STEP 9. Blurring the Black Sandy Text

With Layer 1 still selected in the Layers palette, choose Filter, Blur, Gaussian Blur from the menu bar to open the Gaussian Blur dialog box. Change the Radius setting to 2.8 and then click OK. The copied text now looks like a shadow of the original text.

## STEP 10. Rotating the Shadow

With Layer 1 still selected in the Layers palette, choose Edit, Transform, Rotate from the menu bar. Drag the upper-right handle down to adjust the direction of the shadow as shown here, and then press Enter/Return.

## STEP 11. Inserting the Ant Image

Choose File, Open (Ctrl/Command+O) and open the Book\Sources\ant.jpg file from the supplementary CD-ROM. Click the Magic Wand tool on the toolbox, and then click the white background in the ant image to select the background. Also Shift-click with the Magic Wand in the white space under the ant's neck and the white space between the ant's

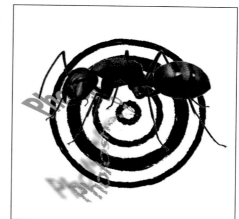

leg and body to add those locations to the selection. Choose Select, Inverse (Shift+Ctrl/Command+I) to invert the selection. Press Ctrl/Command+C to copy the image, and then click the close box on the ant.jpg image window to close the image. Do not save the file if prompted. Press Ctrl/Command+V to paste the ant image on a new layer named Layer 3 in the project file.

## STEP 12. Removing the Ant's Messy Edges

Ctrl/Command-click Layer 3 in the Layers palette to select the ant. Choose Select, Modify, Contract from the menu bar, change the Contract By setting in the Contract Selection dialog box to 1, and then click OK. Photoshop makes the selection marquee one pixel smaller all around the ant. Choose Select, Inverse (Shift+Ctrl/Command+I) to invert the selection, and then press Del to remove the ant's messy edges. Choose Select, Deselect (Ctrl/Command+D) to remove the selection marquee.

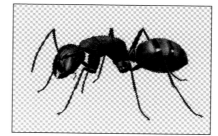

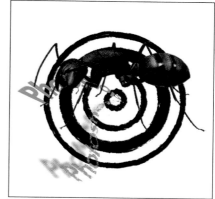

## STEP 13. Coloring the Ant Red

With Layer 3 still selected in the Layers palette, choose Edit, Transform, Scale from the menu bar. Drag a handle to reduce the ant's size, and then press Enter/Return. Choose Layer, New, Layer via Copy (Ctrl/Command+J) to copy the Layer 3 (ant) layer. Ctrl/Command-click the Layer 3 copy (copied ant) layer to make a selection in the shape of the ant. Set the foreground color to red using the Color palette, and use the Paint Bucket tool or press Alt/Option+Del to fill the selection. Choose Select, Deselect (Ctrl/Command+D) to remove the selection marquee.

## STEP 14. Adding a New Layer

Click the Create a new layer button (Shift+Ctrl/Command+N) on the Layers palette to make a new layer. Drag it down in the Layers palette to place it above the Background layer with the circles at the bottom of the palette. Click the eye icon beside each layer except the new layer, hiding the other layers.

## STEP 15. Filling the New Layer

Click the Set foreground color button on the toolbox to open the Color Picker dialog box. Specify a dark greenish brown color as shown here, and then click OK. Use the Paint Bucket tool or press Alt/Option+Del to fill the layer with the foreground color.

## STEP 16. Adding a Sandy Texture

Choose Filter, Render, Clouds from the menu bar to create a cloud texture on the new layer. Choose Filter, Pixelate, Mezzotint, and then click OK to convert the cloudy texture to a grainy texture.

## STEP 17. Completing the Sandy Texture Effect

Choose Filter, Sketch, Bas Relief from the menu bar to open the Bas Relief dialog box. Specify the settings shown here in the dialog box, and then click OK. To adjust the sand's color, choose Image, Adjustments, Hue/Saturation (Ctrl/Command+U). Specify the settings shown here in the Hue/Saturation dialog box, and then click OK.

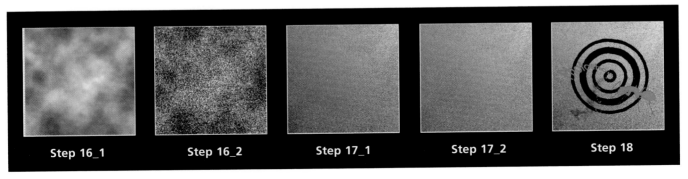

Step 16_1    Step 16_2    Step 17_1    Step 17_2    Step 18

## STEP 18. Adjusting the Brightness and Contrast of the Sand Texture

Choose Image, Adjustments, Curves (Ctrl/Command+M) from the menu bar to open the Curves dialog box. In the Curves dialog box, bend the curve into the shape shown here. To do so, click the diagonal line to create two points on the curve, and then drag them into position. Click OK to apply the changes. Drag the sandy texture layer to the bottom of the Layers palette. Click the Layer 1 layer to both select and redisplay it. Click the Add a layer style button at the bottom of the Layers palette, and then click Blending Options. In the Layer Style dialog box, choose Darken from the Blend Mode drop-down list, and then click OK. Redisplay each of the other layers by clicking the eye icon box beside it.

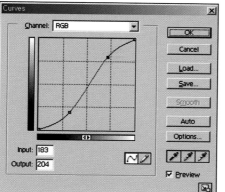

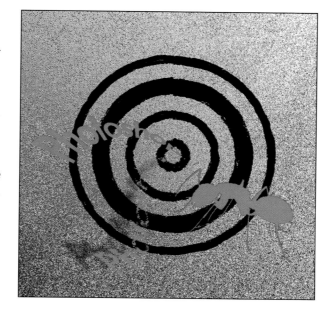

## STEP 19. Removing a Portion of the Sand Texture

Click the Layer 4 layer in the Layers palette to select that layer. Choose the Lasso Tool from the toolbox, and make a selection like the one shown here. Press the Del key. Choose Select, Deselect (Ctrl/Command+D) to remove

  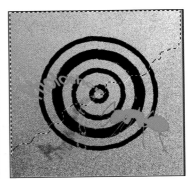

the selection marquee. Click the Add a layer style button at the bottom of the Layers palette, and then click Drop Shadow. In the Layer Style dialog box, change the Opacity setting to 54% and the Angle setting to 27, and then click OK.

## STEP 20. Making the Ant's Shadow

Click Layer 3 in the Layers palette to select that layer, and then click the Create a new layer button (Shift+Ctrl/Command+N) to add a new layer named Layer 5 above the original ant layer. Ctrl/Command-click the Layer 3 copy (red ant) layer to make a selection in the shape of the ant on the new layer. Use the Color palette to specify a gray foreground color, and then use the Paint Bucket tool or press Alt/Option+Del to fill the selection. Choose Select, Deselect (Ctrl/Command+D) to remove the selection marquee.

 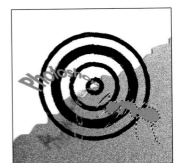

## STEP 21. Slanting the Ant's Shadow

With Layer 5 still selected in the Layers palette, choose Edit, Transform, Skew from the menu bar. Drag the top of the bounding box and the top corner handles to skew that shadow approximately as shown here, and then press Enter/Return. Choose Filter, Blur, Gaussian Blur to open the Gaussian Blur dialog box. Change the Radius setting to approximately 3.3, and then click OK to blur the shadow.

 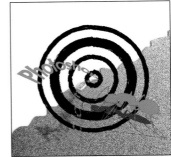

## STEP 22. Completing the Ant's Shadow

With Layer 5 still selected, click the Add a layer style button at the bottom of the Layers palette, and then click Blending Options. In the Layer Style dialog box, choose Multiply from the Blend Mode drop-down list, and then click OK. The ant's shadow layer mixes with the sandy layer so that the texture shows through.

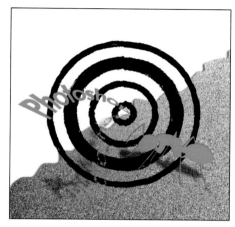

## STEP 23. Entering the Text to Complete the Image

Set the foreground color to black by clicking the Default Foreground and Background Colors button on the toolbox, and then choose the Horizontal Type tool from the toolbox. Click the Toggle the Character and Paragraphs palette button on the Options bar to open the Character palette, if needed. Specify the font and font settings shown here in the Character palette. Click in the image window, enter the text as shown, and click the Commit any current edits button on the Options bar.

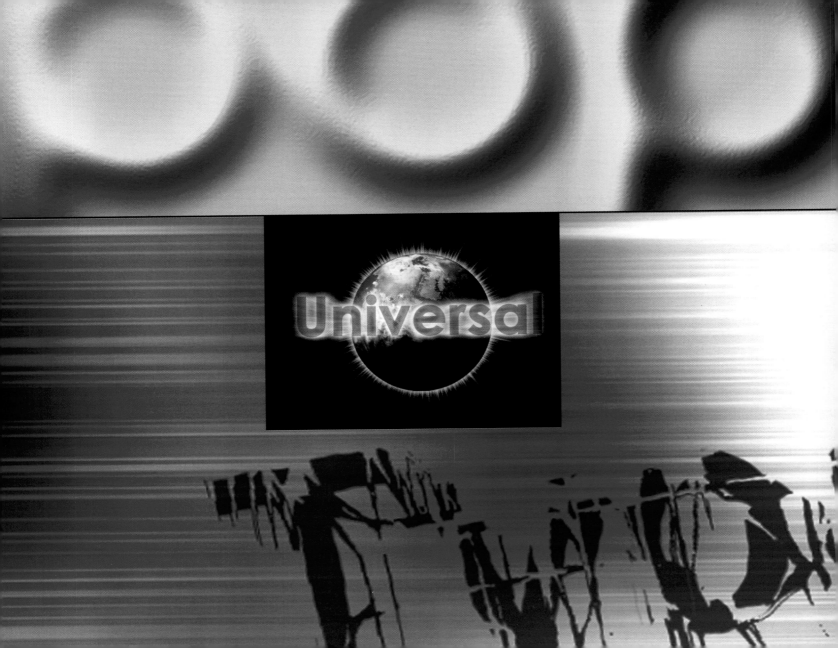

# Project 17: Universal Light

In this chapter, create a windblown light that appears to originate behind an object. This technique adds depth to the image. Also use layer blending modes and opacity settings to create text that appears to be made of light.

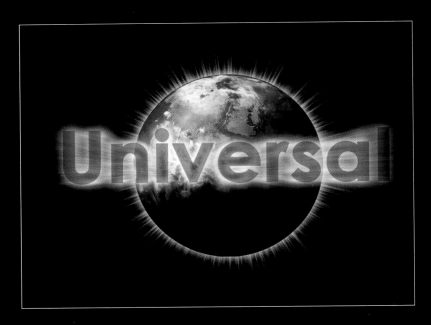

Universal Light

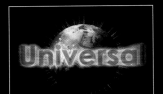
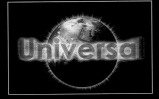

# Project 17: Universal Light

## Total Steps

STEP 1.    Adding Text in a New Image
STEP 2.    Blurring the Text
STEP 3.    Making the Text Outline
STEP 4.    Applying the Wind Filter to the Text
STEP 5.    Rotating the Image and Applying the Wind Filter
STEP 6.    Rotating the Image and Applying the Wind Filter Again
STEP 7.    Rotating the Image and Applying the Wind Filter Yet Again
STEP 8.    Spreading the Light
STEP 9.    Adding Color to the Text
STEP 10.   Adjusting the Text Transparency

STEP 11.   Colorizing the Light
STEP 12.   Illuminating the Edges of the Text
STEP 13.   Inserting the Earth Image
STEP 14.   Arranging the Earth Image
STEP 15.   Sending the Earth Image Back
STEP 16.   Making the Background Black
STEP 17.   Sharpening the Earth Image
STEP 18.   Adding a New Layer
STEP 19.   Applying the Wind Filter to the New Layer
STEP 20.   Creating a Light Burst
STEP 21.   Blending the Circular Light Image
STEP 22.   Adding a Glow to the Earth

## STEP 1. Adding Text in a New Image

Choose File, New (Ctrl/Command+N) from the menu bar to open the New dialog box. Set the Width to 800 pixels and the Height to 600 pixels. Set the Resolution to 100 pixels/inch, and then click OK. Click the Default Foreground and

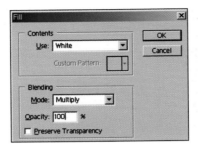

Background Colors button on the toolbox, and then choose the Horizontal Type tool from the toolbox. Click the Toggle the Character and Paragraphs palette button on the Options bar to open the Character palette, if needed. Specify the font and font settings shown here in the Character palette. Click in the image window, enter the text as shown, and click the Commit any current edits button on the Options bar. Choose Layer, New, Layer via Copy (Ctrl/Command+J) to copy the text layer. Click the Create a new layer button (Shift+Ctrl/Command+N) in the Layers palette to make a new layer named Layer 1. Drag Layer 1 above the Background layer in the Layers palette. Click the Switch Foreground and Background Colors button on the toolbox to set the foreground color to white, and then press Alt/Option+Del to fill the new layer with white. Click the original text (Universal) layer in the Layers palette. Choose Layer, Merge Down (Ctrl/Command+E) from the menu bar to merge the layers. Click the eye icon beside the Universal copy layer to hide it.

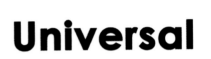

## STEP 2. Blurring the Text

Double-click the Layer 1 layer name, type "Universal" as the new layer name, and then press Enter/Return to rename the layer. With the Universal layer still selected in the Layers palette, choose Filter, Blur, Gaussian Blur to open the Gaussian Blur dialog box. Set the Radius to 5 and then click OK to blur the text.

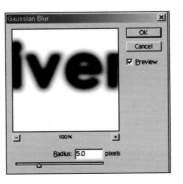

## STEP 3. Making the Text Outline

Choose Filter, Stylize, Solarize from the menu bar to make the edges of the text white. Choose Image, Adjustments, Auto Levels (Shift+Ctrl/Command+L) to optimize the outline's brightness.

 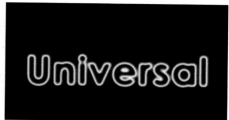

## STEP 4. Applying the Wind Filter to the Text

Choose Filter, Stylize, Wind from the menu bar to open the Wind dialog box. Choose the settings shown here, and then click OK to apply the wind to the text.

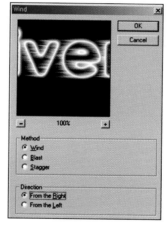 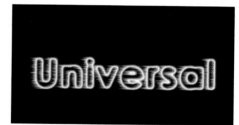

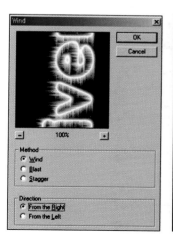 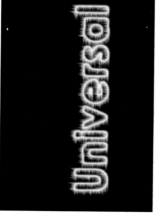

## STEP 5. Rotating the Image and Applying the Wind Filter

Choose Image, Rotate Canvas, 90°CW from the menu bar to rotate the image. Choose Filter, Stylize, Wind, and then click OK in the Wind dialog box.

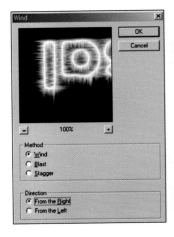

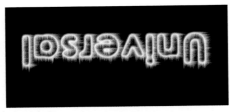

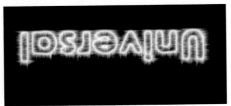

## STEP 6. Rotating the Image and Applying the Wind Filter Again

Choose Image, Rotate Canvas, 90°CW from the menu bar to rotate the image again. Choose Filter, Stylize, Wind, and then click OK in the Wind dialog box.

## STEP 7. Rotating the Image and Applying the Wind Filter Yet Again

Choose Image, Rotate Canvas, 90°CW from the menu bar yet again to rotate the image. Choose Filter, Stylize, Wind, and then click OK in the Wind dialog box. You now have created a windy light effect on each side of the text. Choose Image, Rotate Canvas, 90°CW one last time to rotate the image to its original orientation.

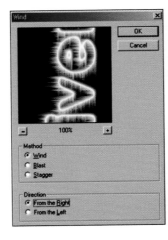

## STEP 8. Spreading the Light

Choose Filter, Blur, Radial Blur from the menu bar to open the Radial Blur dialog box. Choose the settings shown here in the dialog box, and then click OK to apply the blur. The text now looks as if it is moving rapidly toward or away from you.

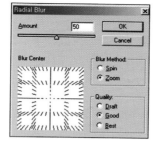

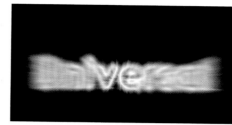

## STEP 9. Adding Color to the Text

Click the Universal copy layer in the Layers palette to both select and redisplay that layer. Choose the Horizontal Type tool in the toolbox, if needed, and then use the Character palette to change the text to the

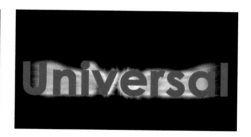

color shown here. Double-click the layer's name, type "Universal copy" as the new layer name, and then press Enter/Return to rename the layer.

## STEP 10. Adjusting the Text Transparency

With the Universal copy layer still selected, click the Add a layer style button at the bottom of the Layers palette, and then click Blending Options. In the Layer Style dialog box, choose Multiply from the Blend Mode drop-down list, change the Opacity to 40%, and then click OK. The text becomes semi-transparent.

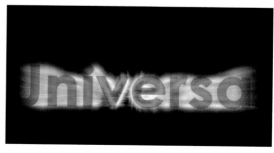

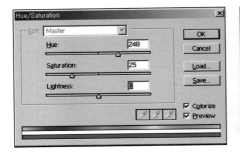

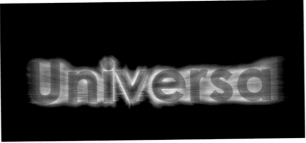

## STEP 11. Colorizing the Light

Click the Universal layer in the Layers palette. Choose Image, Adjustments, Hue/Saturation (Ctrl/Command+U) from the menu bar to open the Hue/Saturation dialog box. Click the Colorize check box to check it, drag the sliders to adjust the settings as shown here, and then click OK.

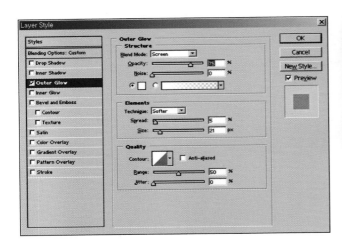

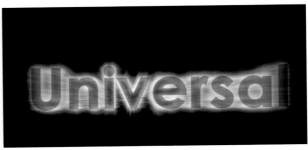

## STEP 12. Illuminating the Edges of the Text

Click the Universal copy layer in the Layers palette. Click the Add a layer style button, and then click Outer Glow. Choose the settings shown here in the Layer Style dialog box, and then click OK.

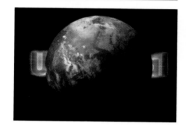

## STEP 13. Inserting the Earth Image

Choose Window, File Browser, and then use the File Browser window to open the Book\Sources\earth.jpg file from the supplementary CD-ROM. Choose Window, File Browser again to close the File Browser. Working in the earth.jpg image window, choose the Elliptical Marquee tool from the toolbox. Press and hold the Shift key while you drag to create a circular selection marquee around the earth only. (Drag the selection to reposition it, if needed.) Press Ctrl/Command+C to copy the selection. Choose File, Close and close the earth.jpg image file without attempting to save changes. Press Ctrl/Command+V to paste the earth image into a new layer named Layer 1 by default. Double-click the Layer 1 layer name, type "earth" as the new layer name, and then press Enter/Return to rename the layer.

## STEP 14. Arranging the Earth Image

Choose Edit, Free Transform (Ctrl/Command+T) from the menu bar, press and hold the Shift key, and drag a corner handle to reduce the size of the earth. Drag the earth to align it with the center of the text, and then press Enter/Return to finish the transformation. Ctrl/Command-click the earth layer in the Layers palette to select only the earth image on the layer. Choose Select, Modify, Contract from the menu bar to open the Contract Selection dialog box. Change the Contract By setting to 1, and then click OK to reduce the selection size by one pixel all around. Choose Select, Inverse (Shift+Ctrl/Command+I), and then press the Del key to clean up the edges of the earth image. Choose Select, Deselect (Ctrl/Command+D) to remove the selection marquee.

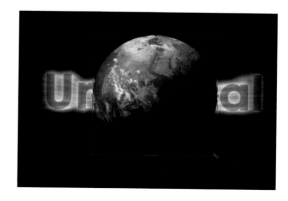

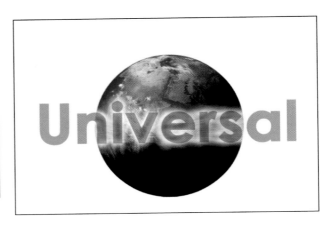

## STEP 15. Sending the Earth Image Back

In the Layers palette, drag the earth layer to move it to just above the Background layer. Click the Universal layer to select it. Click the Add a layer style button at the bottom of the Layers palette, and then click Blending Options. In the Layer Style dialog box, choose Screen from the Blend Mode drop-down list, and then click OK. The earth now appears behind the text.

## STEP 16. Making the Background Black

Click the Background layer in the Layers palette to select that layer. Click the Default Foreground and Background Colors button on the toolbox to reset the foreground color to black. Use the Paint Bucket tool or press Alt/Option+Del to fill the Background layer with black.

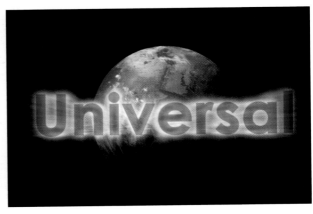

## STEP 17. Sharpening the Earth Image

Click the earth layer in the Layers palette to select that layer. Choose Layer, New, Layer via Copy (Ctrl/Command+J) to copy the layer. With the new earth copy layer selected in the Layers palette, click the Add a layer style button at the bottom of the Layers palette, and then click Blending Options. In the Layer Style dialog box, choose Overlay from the Blend Mode drop-down list, and then click OK. The earth now appears a bit more sharp and bright behind the text.

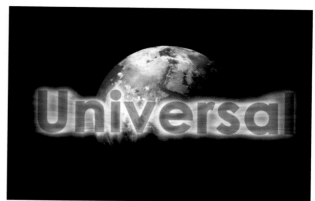

## STEP 18. Adding a New Layer

Click the Create a new layer button (Shift+Ctrl/Command+N) in the Layers palette to add a new layer named Layer 1. Drag Layer 1 to the top of the Layers palette, above the other layers. With black still selected as the foreground color, use the Paint Bucket tool or press Alt/Option+Del to fill the new layer with black. Click the Switch Foreground and Background Colors button on the toolbox to reset the foreground color to white. Choose the Rectangular Marquee tool from the toolbox, and then select the right portion of the layer, as shown here. Use the Paint Bucket tool or press Alt/Option+Del to fill the Background layer with white. Choose Select, Deselect (Ctrl/Command+D) to remove the selection marquee.

## STEP 19. Applying the Wind Filter to the New Layer

Choose Filter, Stylize, Wind from the menu bar, make sure the From the Right option button is selected, and then click OK in the Wind dialog box to add a wind-blown effect to the white area on the layer. Press Ctrl/Command+F four times to reapply the Wind filter, emphasizing the windblown effect.

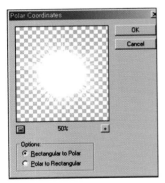

## STEP 20. Creating a Light Burst

Choose Edit, Transform, Rotate 90°CCW to rotate the layer's contents so that the white area now appears at the top of the image window. Choose the Rectangular Marquee tool from the toolbox, press and hold the Shift key, and drag in the layer to make a square selection that includes the full white bar and the black area beneath it, down to the bottom of the image window. Choose Filter, Distort, Polar Coordinates, and then click OK to make the burst of light shown here. (Change the foreground color to black and use the Paint Bucket tool to fill in any white slivers that remain in the black area of the layer.)

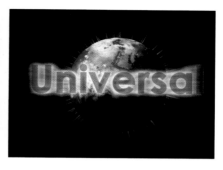

### STEP 21. Blending the Circular Light Image

Choose Select, Deselect (Ctrl/Command+D) to remove the selection marquee. Double-click the Layer 1 layer name, type "Light" as the new layer name, and then press Enter/Return to rename the layer. Drag the Light layer to move it below the earth layer. Click the eye icon beside both the earth and earth copy layers to hide those layers. Use the Rectangular Marquee tool to select only the light burst on the Light layer. Choose Edit, Free Transform (Ctrl/Command+T) from the menu bar, press and hold the Shift key while dragging a corner handle to resize the burst, drag the burst back to the center of the image, and then press Enter/Return. Click the eye icon box beside both the earth and earth copy layers to redisplay those layers and check the position of the burst.

### STEP 22. Adding a Glow to the Earth

Click the earth layer in the Layers palette, click the Add a layer style button at the bottom of the palette, and then click Outer Glow. Make the configurations as shown here to apply an outer glow to the image. Adjust the settings in the Layer Style dialog box as shown here, and then click OK.

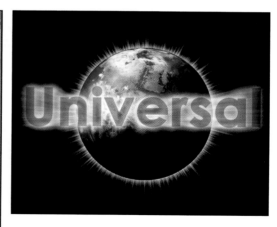

# Project 18: 3-D Block Array

Learn how to create text made from a pattern of 3-D shapes.
Use a perspective transform and shading as a rather simple
way to create 3-D text.

3-D Block Array

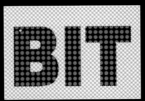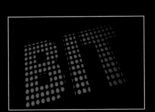

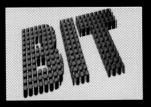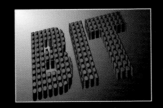

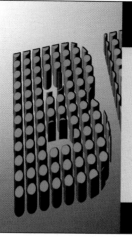

# Project 18: 3-D Block Array

## Total Steps

STEP 1. Creating a New Image with a Gradient Background

STEP 2. Entering the Text

STEP 3. Enlarging the Text

STEP 4. Defining a Circle Pattern

STEP 5. Saving the Circle Pattern

STEP 6. Making a Text-Shaped Selection

STEP 7. Filling the Selection with the Circle Pattern

STEP 8. Copying the Patterned-Text Layer

STEP 9. Adding Perspective to the Text

STEP 10. Creating a Black Background for the Text

STEP 11. Adding Directional Light to the Text

STEP 12. Removing the Black Background

STEP 13. Building the 3-D Effect

STEP 14. Displaying the Background Layer

STEP 15. Adding Text to the Image

STEP 16. Adding a Layer

STEP 17. Adding a White Background

STEP 18. Making a Text-Shaped Selection

STEP 19. Adding Directional Lighting to the Text

STEP 20. Copying and Lighting the Layer

STEP 21. Making Sunken Text

STEP 22. Completing the Sunken Text

STEP 23. Completing the Image

## STEP 1. Creating a New Image with a Gradient Background

Choose File, New (Ctrl/Command+N) from the menu bar to open the New dialog box. Set the Width to 800 pixels and the Height to 600 pixels. Set the Resolution to 100 pixels/inch, and then click OK. Click the Default Foreground and Background Colors button on the toolbox, and then click the Switch Foreground and Background Colors to ensure you've set the foreground color to white and the background color to black. Choose the Gradient tool from the toolbox, and then click the Radial Gradient button in the Options bar. Drag from the upper-left corner to the lower-right corner of the Background layer to create a gradient that is light in the upper-left corner and dark in the lower-right corner of the layer. Double-click the Background layer's name, type "Layer 1" as the new layer name, and then press Enter/Return to rename the layer and convert it to a regular layer.

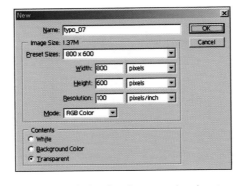

## STEP 2. Entering the Text

Click the Default Foreground and Background Colors button on the toolbox to reset the foreground color to black. Choose the Horizontal Type tool from the toolbox. Click the Toggle the Character and Paragraphs palette button on the Options bar to open the Character palette, if needed. Specify the font and font settings shown here in the Character palette. Click in the image window, type "BIT," and click the Commit any current edits button on the Options bar.

## STEP 3. Enlarging the Text

Choose Edit, Transform, Scale from the menu bar. Drag the handles that appear to enlarge the text to fill the image window, as shown here. Press Enter/Return to finish the transformation.

## STEP 4. Defining a Circle Pattern

You need to create the pattern to apply to the text. Click the Create a new layer button (Ctrl/Command+N) on the Layers palette to add a new layer named Layer 2. With the new layer still selected, choose the Elliptical Marquee tool from the tool-box. Press and hold the Shift key, and then drag in the image window to create a small circular selection, as shown here. Because you'll be creating a pattern to fill the letters with these circles, make sure the selection is small enough that it would fit several times within the width of each letter, as shown here. In the Layers palette, click the eye icon beside Layer 1 and the BIT (text) layer to hide them.

## STEP 5. Saving the Circle Pattern

Use the Color palette to set the foreground color to red, and then use the Paint Bucket tool or press Alt/Option+Del to fill the selection marquee with red. Choose the Rectangular Marquee tool from the toolbox, and select the red dot and some space around it. Move the selection marquee so that its upper and left sides touch the dot. The blank space you allow at the lower-right will determine the space between dots in the pattern. Choose Edit, Define Pattern. Type a name for the pattern in the Pattern Name dialog box, and then click OK. Press the Del key to remove the original dot.

## STEP 6. Making a Text-Shaped Selection

With Layer 2 still selected in the Layers palette, Ctrl/Command-click the BIT layer to make a selection in the shape of the letters.

## STEP 7. Filling the Selection with the Circle Pattern

Choose Edit, Fill from the menu bar to open the Fill dialog box. Choose Pattern from the Use drop-down list, click the Custom Pattern box, and then double-click the pattern you saved in Step 5 to select it and close the palette. Click OK to close the dialog box and fill the selection with the pattern. Choose Select, Deselect (Ctrl/Command+D) to remove the selection marquee.

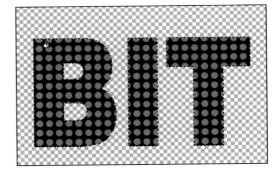

## STEP 8. Copying the Patterned-Text Layer

With Layer 2 still selected, choose Layer, New, Layer via Copy (Ctrl/Command+J) to create a copy of the layer named Layer 2 copy. Having two copies of the patterned-text layer will come in handy later.

## STEP 9. Adding Perspective to the Text

In the Layers palette, click the eye icon beside each layer except the new Layer 2 copy layer to hide those layers. Click the Layer 2 copy layer to select it, if needed. Choose Edit, Transform, Perspective. Drag the upper-left handle to the right to narrow the top dimension of the text, so that it appears tilted back or away. Press Enter/Return. Choose Edit, Transform, Rotate. Drag a handle on the right to slant the text up slightly, as shown here. Press Enter/Return. With Layer 2 copy still selected, choose Layer, New, Layer via Copy (Ctrl/Command+J) to create a copy of the layer named Layer 2 copy 2.

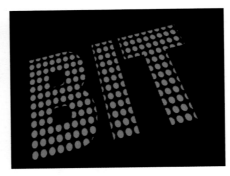

## STEP 10. Creating a Black Background for the Text

Click the Create a new layer button (Shift+Ctrl/Command+N) on the Layers palette to make a new layer named Layer 3. Drag the Layer 3 layer below the Layer 2 copy 2 layer you created in Step 9. Click the Default Foreground and Background Colors button on the toolbox to reset the foreground color to black, and then use the Paint Bucket tool or press Alt/Option+Del to fill the new layer with black. Click the Layer 2 copy 2 layer in the Layers palette, and then click the empty box beside it so that a link icon appears. This links the top two layers. Then, choose Layer, Merge Linked (Ctrl/Command+E) to merge the linked layers into a single layer named Layer 2 copy 2.

## STEP 11. Adding Directional Light to the Text

With the Layer 2 copy 2 layer still selected in the Layers palette, choose Filter, Render, Lighting Effects from the menu bar to open the Lighting Effects dialog box. Adjust the handles in the Preview area as shown here to redirect the "light" to shine from the left and to make the "light" more focused. Choose Red from the Texture Channel drop-down list, and then click OK.

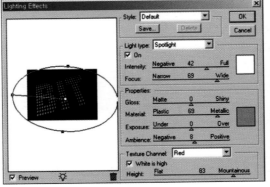

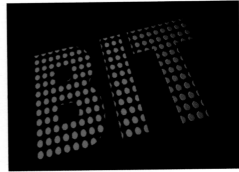

## STEP 12. Removing the Black Background

With the Layer 2 copy 2 layer still selected in the Layers palette, Ctrl/Command-click the Layer 2 copy layer below to select the red dots of the pattern. Choose Select, Inverse (Shift+Ctrl/Command+I) from the menu bar. Press the Del key to remove the black fill while leaving the dots in place.

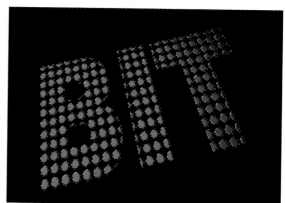

## STEP 13. Building the 3-D Effect

Next, copy and layer the dots in the image to build the 3-D effect. With the Layer 2 copy 2 layer still selected in the Layers palette, choose the Move tool from the toolbox. Press and hold the Alt/Option key, and press the ↑ arrow key. This copies the selected image and piles the copy on top of the original image to create a 3-D effect. You control the number of copies made—and thus how high the "pile" becomes—based on the number of times you press Alt+↑, so repeat that key combination until the text reaches the desired appearance. Choose Select, Deselect (Ctrl/Command+D) to remove the selection marquee.

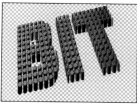

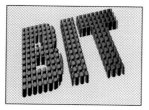

## STEP 14. Displaying the Background Layer

Click the eye icon box beside the Background layer in the Layers palette. The gradient background appears.

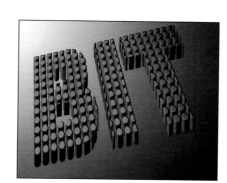

## STEP 15. Adding Text to the Image

Click the Default Foreground and Background Colors button on the toolbox to reset the foreground color to black. Choose the Horizontal Type tool from the toolbox. Specify the desired font and font settings in the Character palette. Click in the image window, type the text shown in the lower-right corner here, and click the Commit any current edits button on the Options bar.

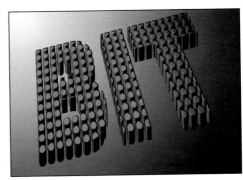

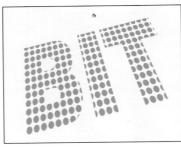

## STEP 16. Adding a Layer

Repeat the process to create 3-D text in the opposite direction, lending additional depth to the image. Click the Layer 2 copy layer in the Layers palette to select that layer. Choose Layer, New, Layer via Copy (Ctrl/Command+J) to create a copy of the layer named Layer 2 copy 3. Drag the new layer to the top of the Layers palette. Click the eye icon beside each of the other layers to hide all but the Layer 2 copy 3 layer.

## STEP 17. Adding a White Background

Click the Create a new layer button (Shift+Ctrl/Command+N) in the Layers palette to add a new layer named Layer 3. Click the Switch Foreground and Background Colors button on the toolbox to set the foreground color to white, and then use the Paint Bucket tool or press Alt/Option+Del to fill the layer with white. Drag the new layer below the Layer 2 copy 3 layer you made in Step 16. Click the Layer 2 copy 3 layer to select it, and then click the box beside Layer 3 so that a link icon appears, indicating that you've linked the layers. Choose Layer, Merge Linked (Ctrl/Command+E) to merge the linked layers.

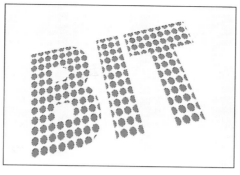

## STEP 18. Making a Text-Shaped Selection

With Layer 2 copy 3 still selected in the Layers palette, Ctrl/Command-click the Layer 2 copy layer to select the red dots forming the letters.

## STEP 19. Adding Directional Lighting to the Text

With the Layer 2 copy 3 layer still selected in the Layers palette, choose Select, Inverse (Shift+Ctrl/Command+I) from the menu to invert the selection. Choose Filter, Render, Lighting Effects from the menu bar to open the Lighting Effects dialog box. Adjust the handles in the Preview area as shown here to redirect the "light" to shine from the upper-left corner and to make the "light" more diffuse. Choose Red from the Texture Channel drop-down list, and then click OK

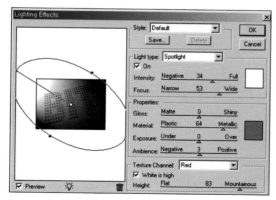

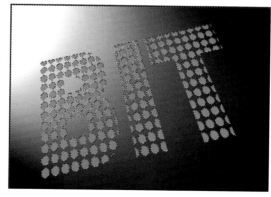

## STEP 20. Copying and Lighting the Layer

With the Layer 2 copy 3 layer still selected in the Layers palette, choose Layer, New, Layer via Copy (Ctrl/Command+J) to create a copy of the layer named Layer 2 copy 4. Choose Select, Inverse (Shift+Ctrl/Command+I) from the menu bar to select the dots. Choose Filter, Render, Lighting Effects from the menu bar to open the Lighting Effects dialog box. Adjust the handles in the Preview area as shown here to redirect the "light" to shine from the lower-right corner and to make the "light" more diffuse. Choose Red from the Texture Channel drop-down list, and then click OK.

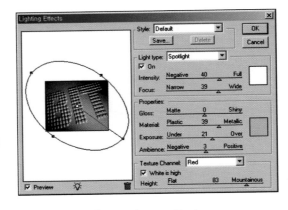

## STEP 21. Making Sunken Text

Choose the Move tool from the toolbox. Press Alt/Option+↓ and Alt/Option+→ one time each to sink the text into the background. With Layer 2 copy 4 still selected, Ctrl/Command-click the Layer 2 copy layer in the Layers palette to move the selection marquee, and press the Del key to erase the selected areas.

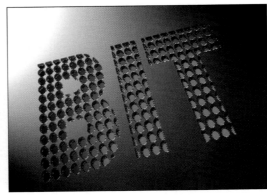

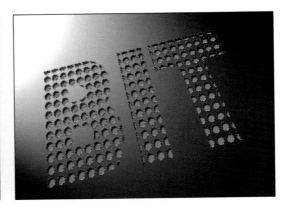

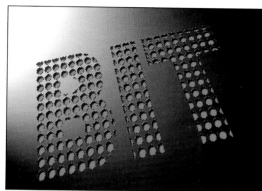

## STEP 22. Completing the Sunken Text

With the Layer 2 copy 4 layer still selected in the Layers palette, click on the box beside the Layer 2 copy 3 layer so that a link icon appears, indicating the layers are linked. Choose Layer, Merge Linked (Ctrl/Command+E) to merge the linked layers.

## STEP 23. Completing the Image

Choose Select, Deselect (Ctrl/Command+D) to remove the selection marquee. In the Layers palette, drag the Layer 2 copy 4 layer down to place it above the Layer 2 copy 2 layer. Click the eye icon box beside the following layers to redisplay them, if needed: Layer 1, Layer 2 copy, Layer 2 copy 2, and PED Photoshop Effect Design. With Layer 2 copy still selected, click the Add a layer style button at the bottom of the Layers palette, and then click Blending Options. In the Layer Style dialog box, choose Overlay from the Blend Mode drop-down list, change the Opacity setting to 50%, and then click OK.

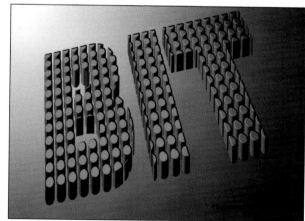

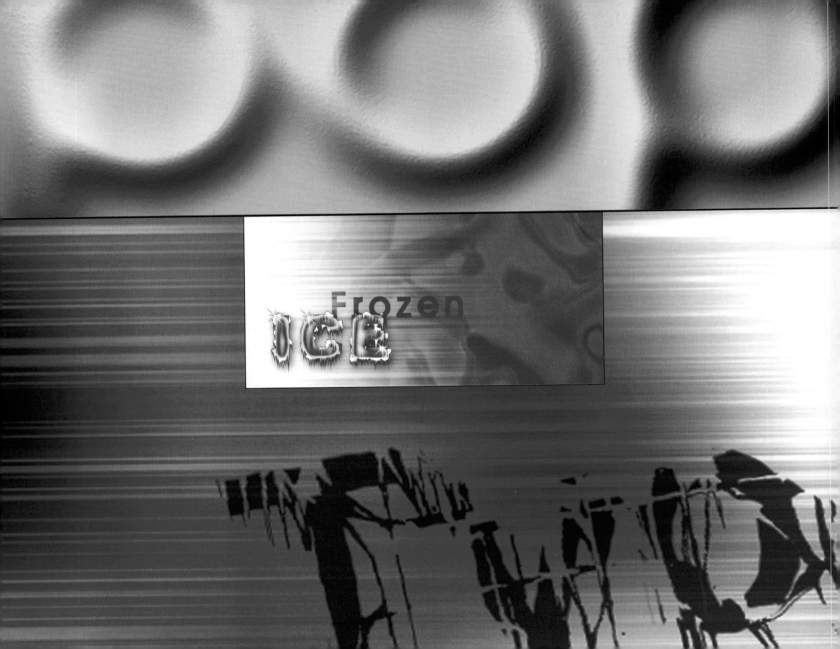

Frozen
ICE

# Project 19: Ice Type

In this chapter, several filters will be used to create an ice type. Also, we will learn various ways to restore image brightness using Curve, Level, and other commands.

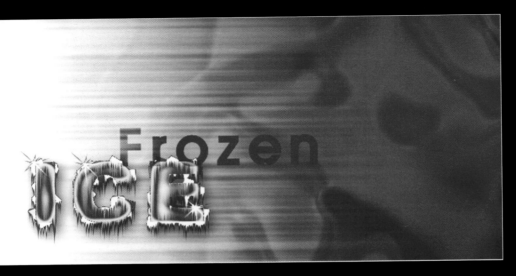

Ice Type

 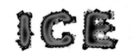 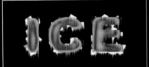

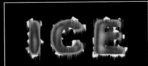 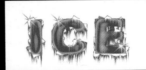 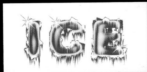

   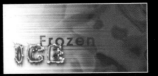

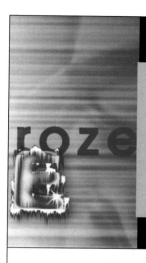

# Project 19: Ice Type

## Total Steps

STEP 1.   Entering Text in a New Image
STEP 2.   Choosing a Text-Shaped Selection
STEP 3.   Texturizing the Text
STEP 4.   Adding Noise to the Text
STEP 5.   Blurring the Inside of the Text
STEP 6.   Icing the Text
STEP 7.   Inverting and Rotating the Image
STEP 8.   Applying the Wind Filter
STEP 9.   Making the Icy Text Blue
STEP 10.  Making Twinkling Light Shapes
STEP 11.  Making a Text-Shaped Selection
STEP 12.  Removing the Black Background
STEP 13.  Sharpening the Icy Text

STEP 14.  Widening and Texturizing the Image
STEP 15.  Blurring the Cloud Texture
STEP 16.  Applying the Chrome Filter to Simulate Liquid
STEP 17.  Lowering the Contrast of the Background Texture
STEP 18.  Adding a Bluish Tone to the Texture
STEP 19.  Applying a Mask to the Texture
STEP 20.  Adding a White Background Layer
STEP 21.  Adding Horizontal Stripes to the Image
STEP 22.  Adding Light Ray Effects to the Texture
STEP 23.  Blending the Ice Text and the Texture
STEP 24.  Adding More Text

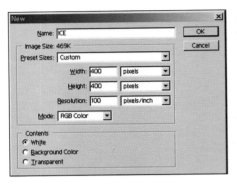
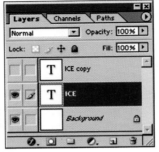
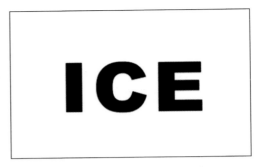

## STEP 1. Entering Text in a New Image

Choose File, New (Ctrl/Command+N) to open the New dialog box. Set both the Width and Height to 400 pixels, and the Resolution to 100 pixels/inch. Click OK. Click the Default Foreground and Background Colors button on the toolbox to reset the foreground color to black. Choose the Horizontal Type tool from the toolbox. Click the Toggle the Character and Paragraphs palette button on the Options bar to open the Character palette, if needed. Specify the desired font and font settings in the Character palette. Click in the image window, type "ICE," and click the Commit any current edits button on the Options bar. With the ICE layer selected, choose Layer, New, Layer via Copy (Ctrl/Command+J) to copy the layer. Click the eye icon beside the ICE copy layer to hide it, and then click the ICE layer to select it.

## STEP 2. Choosing a Text-Shaped Selection Frame

Choose Layer, Merge Down (Ctrl/Command+E) to merge the ICE layer with the Background layer. Double-click the Background layer's name, type "ICE" as the new layer name, and then press Enter/Return to rename the layer and convert it to a regular layer. Ctrl/Command-click the ICE copy layer in the Layers palette to make a selection in the shape of the letters. Choose Select, Inverse (Shift+Ctrl/Command+I) to invert the selection.

## STEP 3. Texturizing the Text

Choose Filter, Pixelate, Crystallize from the menu bar to open the Crystallize dialog box. Change the Cell Size setting to 15, and then click OK. Rough bumps appear around the text edges.

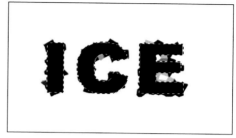

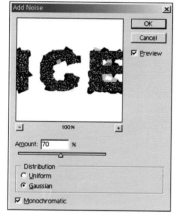

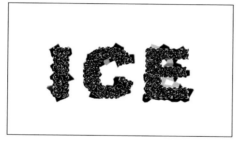

## STEP 4. Adding Noise to the Text

Choose Select, Inverse (Shift+Ctrl/Command+I) to invert the selection. Choose Filter, Noise, Add Noise to open the Add Noise dialog box. Set the Amount to approximately 70, and then click OK. Black and white noise appears inside the text.

## STEP 5. Blurring the Inside of the Text

Choose Filter, Blur, Gaussian Blur from the menu bar to open the Gaussian Blur dialog box. Change the Radius to 9, and then click OK. This blurs the noise inside the text.

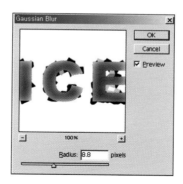

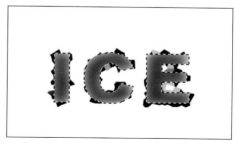

## STEP 6. Icing the Text

Choose Image, Adjustments, Curves (Ctrl/Command+M) from the menu bar to open the Curves dialog box. In the Curves dialog box, bend the curve into the shape shown here. To do so, click the diagonal line to create points on the curve, and then drag them into position. Click OK to apply the changes. A texture like the inside of a block of ice appears inside the text.

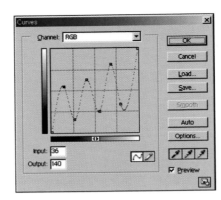

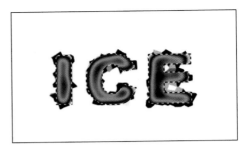

## STEP 7. Inverting and Rotating the Image

Choose Select, Deselect (Ctrl/Command+D) from the menu bar to remove the selection marquee. Choose Image, Adjustments, Invert (Ctrl/Command+I) to invert the image color. The icy texture becomes more apparent. When you next apply the Wind filter, the ice will appear to be melting. Because the Wind filter can only be applied from the left or right, choose Image, Rotate Canvas, 90°CW to rotate the image clockwise 90°.

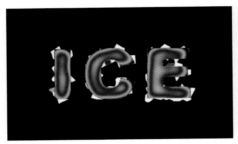

## STEP 8. Applying the Wind Filter

Choose Filter, Stylize, Wind from the menu bar to open the Wind dialog box. Make sure the settings shown here are selected, and then click OK to apply the Wind effect. Then, choose Image, Rotate Canvas, 90° CCW to rotate the image back to its original orientation.

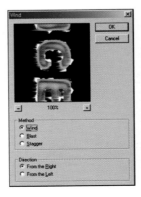

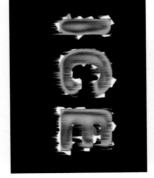

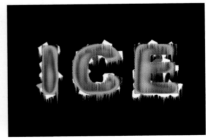

## STEP 9. Making the Icy Text Blue

Choose Image, Adjustments, Hue/Saturation (Ctrl/Command+U) from the menu bar to open the Hue/Saturation dialog box. Click the Colorize check box to check it, drag the sliders to the positions shown here, and then click OK.

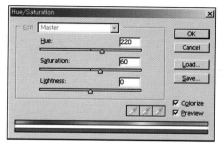

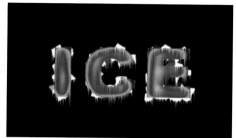

## STEP 10. Making Twinkling Light Shapes

Choose the Brush Tool from the toolbox. Click the Click to open the Brush Preset picker button on the Options bar, click the palette menu button in the upper-right corner, and then click Assorted Brushes. Click OK to replace the current brushes with the selected brushes, and then double-click the Starburst-Small brush shown here to select it and close the preset picker.

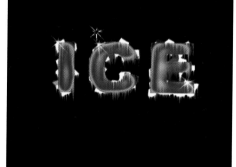

Click the Switch Foreground and Background Colors button on the toolbox to set the foreground color to white, and click here and there on the icy text to add twinkles. To emphasize the twinkling effect, click twice in the same spot. Click the Click to open the Brush Preset picker button on the Options bar, click the palette menu button in the upper-right corner, click Reset Brushes, and then click OK to reselect the original brushes. Close the preset picker.

## STEP 11. Making a Text-Shaped Selection

Click the Create a new layer button (Shift+Ctrl/Command+N)
to add a new layer named Layer 1. Drag it to the very bot-
tom of the Layers palette, and use the Paint Bucket tool or
press Alt/Option+Del to fill it with white. Set the fore-
ground color to white and press Alt+Del to color the new
layer white. Choose Select, Color Range from the menu bar,
click on the black background color in the image window,
change the Fuzziness setting to 200, and then click OK. This
selects only the dark areas around the text. Choose Select,
Inverse (Shift+Ctrl/Command+I) to invert the selection.
Shift+Ctrl/Command-click the ICE copy layer in the Layers
palette to create a selection in the shape of the text and
add it to the current selection.

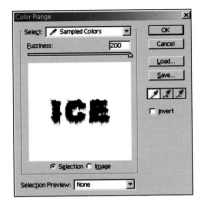

## STEP 12. Removing the Black Background

Click the ICE layer to select it, and
then click the Add layer mask but-
ton on the Layers palette to create
a mask in the shape of the selec-
tion. The mask hides the black
areas, so the white fill from Layer
1 shows instead.

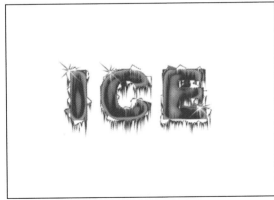

## STEP 13. Sharpening the Icy Text

A layer mask thumbnail now appears to the right of the layer thumbnail on the ICE layer in the Layers palette. Click on the layer thumbnail to enable layer editing. Choose Image,

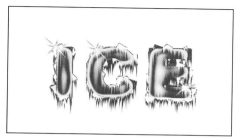

Adjustments, Curves (Ctrl/Command+M) from the menu bar to open the Curves dialog box. In the Curves dialog box, bend the curve into the shape shown here. To do so, click the diagonal line to create points on the curve, and then drag them into position. Click OK to apply the changes. The text color sharpens.

## STEP 14. Widening and Texturizing the Image

Choose Image, Canvas Size from the menu bar to open the Canvas Size dialog box. Increase the Width setting to 800 pixels, and then click OK. Click the eye beside the ICE layer to hide it in addition to the ICE copy layer, which you hid earlier. Click the Layer 1 layer in the Layers palette to select the layer. Click the Default Foreground and Background Colors button on the toolbox. Choose Filter, Render, Clouds to add a cloud texture to Layer 1.

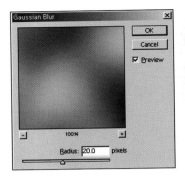

## STEP 15. Blurring the Cloud Texture

Choose Filter, Blur, Gaussian Blur from the menu bar to open the Gaussian Blur dialog box. Set the Radius to 20, and then click OK to blur the texture. Choose Image, Adjustments, Auto Levels (Shift+Ctrl/Command+L) from the menu bar to intensify the texture's shadings.

## STEP 16. Applying the Chrome Filter to Simulate Liquid

Choose Filter, Sketch, Chrome from the menu bar to open the Chrome dialog box. Drag the sliders to specify the settings shown here, and then click OK. The texture changes to look like a liquid surface.

## STEP 17. Lowering the Contrast of the Background Texture

Choose Image, Adjustments, Levels (Ctrl/Command+L) from the menu bar to open the Levels dialog box. Drag the Output Levels sliders to the positions shown here, and then click OK.

## STEP 18. Adding a Bluish Tone to the Texture

Choose Image, Adjustments, Hue/Saturation (Ctrl/Command+U) from the menu bar to open the Hue/Saturation dialog box. Click the Colorize check box to check it, drag the sliders to the settings shown here, and click OK. The texture turns blue.

## STEP 19. Applying a Mask to the Texture

With the Layer 1 layer still selected in the Layers palette, click the Add a layer mask button on the palette to add a mask to the layer. The layer mask thumbnail appears on the layer and is selected or active. You can use it to apply a transparent gradient to the text. Click the Default Foreground and Background Colors button on the toolbox to make the foreground color black and the background color white. Choose the Gradient tool from the toolbox, and then click the Linear Gradient button on the Options bar. Drag over the layer from right to left.

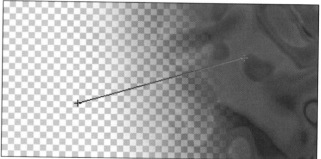

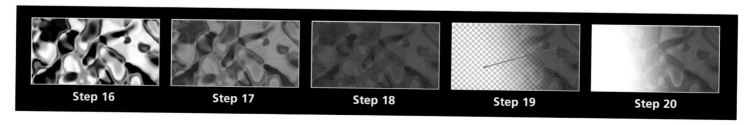

| Step 16 | Step 17 | Step 18 | Step 19 | Step 20 |

## STEP 20. Adding a White Background Layer

Click the Create a new layer button (Shift+Ctrl/Command+N) in the Layers palette to add a new layer named Layer 2. Drag it to the bottom of the Layers palette. Press Ctrl/Command+Del to fill the layer with white, the current background color.

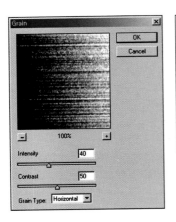

## STEP 21. Adding Horizontal Stripes to the Image

Click the layer mask thumbnail for Layer 1 in the Layers palette so that you can edit the mask. Choose Filter, Texture, Grain from the menu bar to open the Grain dialog box. Choose Horizontal from the Grain Type drop-down list, adjust the slider settings as shown here, and then click OK. Horizontal stripes appear across the mask.

## STEP 22. Adding Light Ray Effects to the Texture

Select Filter, Blur, Motion Blur from the menu bar to open the Motion Blur dialog box. Choose the settings shown here, and then click OK to soften the horizontal grain. This makes it appear as if the blue water ripples are hidden by light.

## STEP 23. Blending the Ice Text and the Background

Click on the eye icon box beside the ICE layer in the Layers palette to redisplay it. Click the ICE layer to select it, and click the Add a layer style button. Click Drop Shadow, and then click OK in the Layer Style dialog box to apply the drop shadow. Use the Move tool from the toolbox to move the icy text to the lower-left corner of the image window.

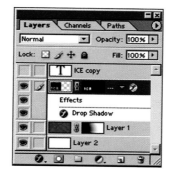

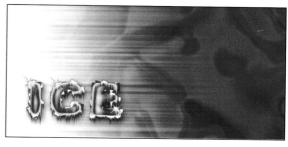

## STEP 24. Adding More Text

Click Layer 2 in the Layers palette to select that layer. Choose the Horizontal Type tool from the toolbox. Specify the font and font settings shown here in the Character palette. (Choose another font if HYTeBack is not available.) Click in the image window, type "Frozen," and click the Commit any current edits button on the Options bar. Click the Add a layer style button on the Layers palette, and click Blending Options. Choose Overlay from the Blend Mode drop-down list, and then click OK. Drag the Frozen text layer above the Layer 1 layer in the Layers palette. If you want to make the text darker, copy the Frozen layer by dragging it onto the Create a new layer button on the Layers palette.

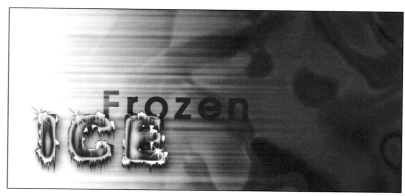

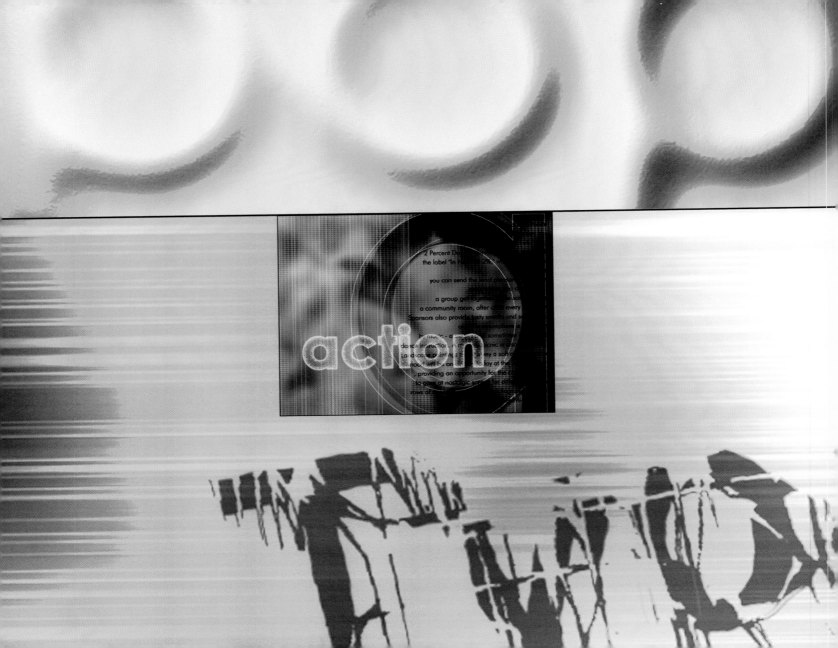

# Project 20: Action Type

Moving a text outline and adding thin vertical lines of text make the text in this project appear to be in motion. Use blending modes and the opacity settings to blend a background picture and text together naturally.

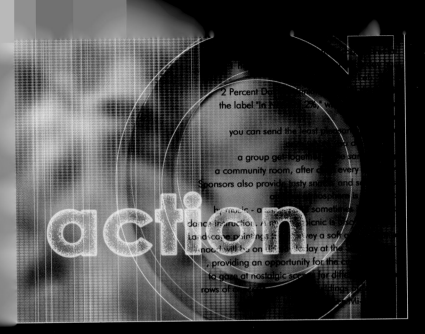

# Project 20: Action Type

## Total Steps

STEP 1. Importing an Image
STEP 2. Blurring the Image
STEP 3. Opening a Second Source Image
STEP 4. Resizing the Second Source Image
STEP 5. Blending the Source Images
STEP 6. Creating a New Image
STEP 7. Creating a White Frame
STEP 8. Saving the Pattern
STEP 9. Applying the Pattern to the Project Image
STEP 10. Adding Lighting to the Pattern
STEP 11. Adjusting the Pattern Transparency
STEP 12. Typing in 'a' and Adjusting the Size
STEP 13. Blending the Text
STEP 14. Making a Text-Shaped Selection
STEP 15. Moving the Text-Shaped Selection

STEP 16. Adding a Border to the Selection
STEP 17. Making a Text-Shaped Selection Again
STEP 18. Adding a Second Border
STEP 19. Making Half of the Image White
STEP 20. Transparently Blending the White Layer
STEP 21. Entering Text
STEP 22. Right-Aligning the Text
STEP 23. Entering the Title
STEP 24. Displaying Only the Title Outline
STEP 25. Adding a Glow to the Title
STEP 26. Adjusting the Title Text Transparency
STEP 27. Adding Vertical Lines
STEP 28. Completing the Line_03 Layer
STEP 29. Naturally Blending the Line_03 Layer

## STEP 1. Importing an Image

Choose File, Open (Ctrl/Command+O) and open the Book\Sources\scenery_02.jpg file from the supplementary CD-ROM. Double-click the Background layer name, type "back_01" as the new layer name, and then press Enter/Return to rename the layer.

## STEP 2. Blurring the Image

Choose Filter, Blur, Gaussian Blur to open the Gaussian Blur dialog box. Change the Radius to 10 and click OK to blur the image.

## STEP 3. Opening a Second Source Image

Choose File, Open (Ctrl/Command+O) and open the Book\Sources\gogh_02.jpg file from the supplementary CD-ROM. Drag from the gogh_02.jpg image window onto the scenery_02.jpg image window to copy the gogh_02.jpg image and place the copy on a new layer in the scenery_02.jpg window. Choose Window, Documents, gogh_02.jpg, and then click the window close box to close the second file.

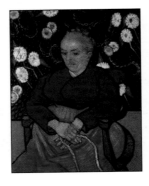

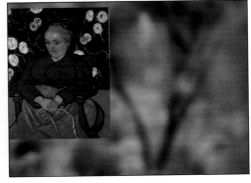

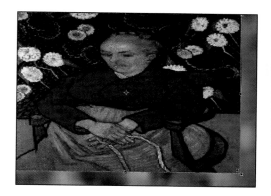

## STEP 4. Resizing the Second Source Image

With the Layer 1 layer selected in the Layers palette, choose Edit, Free Transform (Ctrl/Command+T) from the menu bar, drag the handles to enlarge the image to fill the image window, and then press Enter/Return. Choose Filter, Blur, Gaussian Blur to open the Gaussian Blur dialog box. Set the Radius to 15, and then click OK to blur the image.

## STEP 5. Blending the Source Images

Double-click the Layer 1 layer's name, type 'back_02,' and then press Enter/Return to rename the layer. Click the Add a layer style button on the Layers palette, and click Blending Options. Choose Overlay from the Blend Mode drop-down list, and then click OK.

## STEP 6. Creating a New Image

You need to make a new image window to create a netting pattern. Choose File, New (Ctrl/Command+N) from the menu bar to open the New dialog box. Set the Width to 10 pixels and the Height to 6 pixels. Set the Resolution to 100 pixels/inch, click the Transparent option button, and then click OK. Use the Navigator palette to magnify the image window for ease of use.

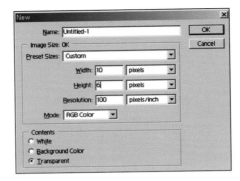

## STEP 7. Creating a White Frame

Choose the Elliptical Marquee tool from the toolbox and make an oval selection as shown here. Choose Select, Inverse (Shift+Ctrl/Command+I) to invert the selection. Click the Switch Foreground and Background Colors button on the toolbox to set the foreground color to white, and then use the Paint Bucket tool or press Alt/Option+Del to fill the selection with white.

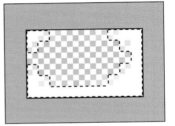

## STEP 8. Saving the Pattern

Choose Select, All (Ctrl/Command+A) from the menu bar. Choose Edit, Define Pattern from the menu bar, type the desired name for the pattern in the Pattern Name dialog box, and then click OK. Click the window close button, and then click No to close the pattern image without saving it.

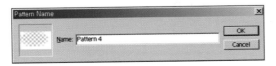

## STEP 9. Applying the Pattern to the Project Image

Click the Create a new layer button
(Shift+Ctrl/Command+N) in the Layers palette
to add a new layer named Layer 1. Choose Edit,
Fill from the menu bar to open the Fill dialog
box. Choose Pattern from the Use drop-down
list, and then click the Custom Pattern box. In
the palette that appears, double-click the pat-
tern you saved in Step 8. Click OK to apply the
pattern to the whole Layer 1 layer.

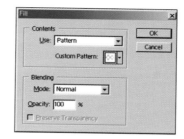

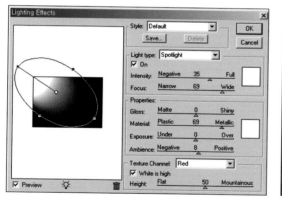

## STEP 10. Adding Lighting to the Pattern

Choose Filter, Render, Lighting Effects from the menu bar bar to open the Lighting
Effects dialog box. Adjust the handles in the Preview area as shown here to redirect
the "light" to shine from the upper-left corner and to make the "light" more
focused. Choose Red from the Texture Channel drop-down list, and then click OK.

## STEP 11. Adjusting the Pattern Transparency

With the Layer 1 layer still selected in the Layers palette, use the Opacity slider on the palette to reduce the layer's opacity to 40%, so the pattern blends with the image layers.

## STEP 12. Typing in 'a' and Adjusting the Size

Click the Default Foreground and Background Colors button on the toolbox to reset the foreground color to black. Choose the Horizontal Type tool from the toolbox. Click the Toggle the Character and Paragraphs palette button on the Options bar to open the Character palette, if needed. Specify the desired font and font settings in the Character palette. Click in the image window, type "a," and click the Commit any current edits button on the Options bar. Choose Edit, Free Transform (Ctrl/Command+T) from the menu bar, drag the handles to adjust the size and position of the letter, and then press Enter/Return. With the a layer selected in the Layers palette, click the Add a layer style button, and click Drop Shadow. Choose the settings shown here in the Layer Style dialog box, and then click OK.

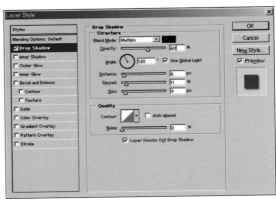

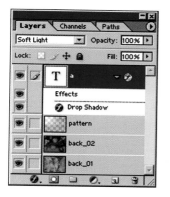

## STEP 13. Blending the Text

Click the Add a layer style button on the Layers palette, and click Blending Options. Choose Soft Light from the Blend Mode drop-down list, and then click OK.

## STEP 14. Making a Text-Shaped Selection

Ctrl/Command-click the a layer in the Layers palette to make a selection in the shape of the letter.

## STEP 15. Moving the Text-Shaped Selection

Click the Create a new layer button (Shift+Ctrl/Command+N) in the Layers palette to add a new layer named Layer 2. Double-click the layer name, type "Line_01," and then press Enter/Return to rename the layer. Choose the Rectangular Marquee tool from the toolbox, and drag the selection marquee to the left.

## STEP 16. Adding a Border to the Selection

Click the Switch Foreground and Background Colors button on the toolbox to set the foreground color to white. Choose Edit, Stroke from the menu bar to open the Stroke dialog box. Choose the settings shown here, and then click OK to establish a thin white outline of the letter on the Line_01 layer.

## STEP 17. Making Another Text-Shaped Selection

Click the Create a new layer button (Ctrl/Command+N) in the Layers palette to add a new layer named Layer 2. Double-click the layer name, type "Line_02," and then press Enter/Return to rename the layer. Ctrl/Command-click the a layer in the Layers palette to again make a selection in the shape of the letter. With the Rectangular marquee tool still selected, drag the selection marquee to the right.

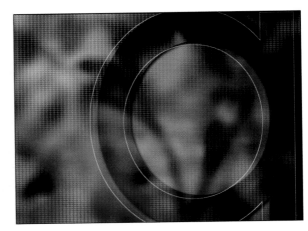

## STEP 18. Adding a Second Border

Choose Edit, Stroke from the menu bar, make sure the Stroke dialog box settings match those shown here, and then click OK. Another thin border in the shape of the

letter appears. Choose Select, Deselect (Ctrl/Command+D) to remove the selection marquee. With the Line_02 layer still selected in the Layers palette, click the Add a layer style button, and then click Blending Options. Choose Overlay from the Blend Mode drop-down list, and then click OK to apply a subtle blend to the second border.

## STEP 19. Making Half of the Image White

Click the Create a new layer button (Shift+Ctrl/Command+N) in the Layers palette to add a new layer named Layer 2. Choose the Rectangular Marquee tool from the toolbox, and make a rectangular selection on the left side of the image as shown here. With white still selected as the foreground color, use the Paint Bucket tool or press Alt/Option+Del to fill the selection with white.

## STEP 20. Transparently Blending the White Layer

Double-click the Layer 2 layer name, type "shell," and press Enter/Return to rename the layer. Use the Opacity slider on the Layer palette to reduce the layer's opacity to 20%, so the image color shows through the white selection. Choose Select, Deselect (Ctrl/Command+D) to remove the selection marquee.

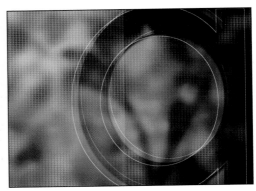

## STEP 21. Entering Text

Click the Default Foreground and Background Colors button on the toolbox to reset the foreground color to black. Choose the Horizontal Type tool from the toolbox. Specify the font and font settings shown here in the Character palette, choosing another font if Futura is not available. Click in the image window, type the text shown here, and click the Commit any current edits button on the Options bar.

## STEP 22. Right-Aligning the Text

With the Horizontal Text tool still selected, click the Right align text button on the Options bar. Choose the Move tool from the toolbox, and drag the text to the right side of the layer.

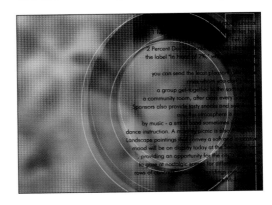

## STEP 23. Entering the Title

Click the shell layer in the Layers palette to select that layer. Choose the Horizontal Type tool from the toolbox, and then adjust the Character palette setting as shown here. Click the Left align text button on the Options bar. Click in the image window, type "action," and click the Commit any current edits button on the Options bar.

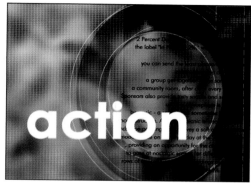

## STEP 24. Displaying Only the Title Outline

With the action layer selected in the Layers palette, click the Add a layer style button on the Layers palette, and then click Stroke. Set the Size to 5 and use the Color box to change the stroke color to white. Click OK. Use the Fill slider in the Layers palette to change the layer's Fill value to 12%, so the inside of the title text becomes transparent.

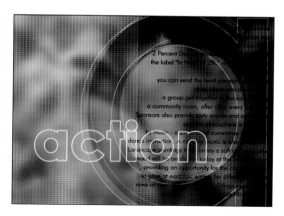

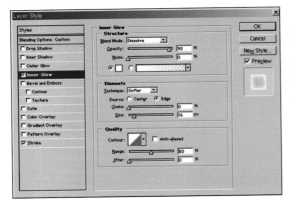
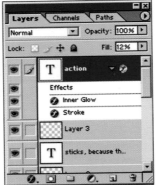
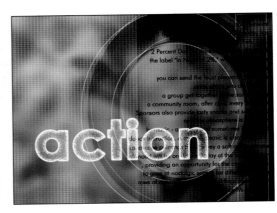

## STEP 25. Adding a Glow to the Title

With the action layer still selected in the Layers palette, click the Add a layer style button again, and choose Inner Glow. Adjust the settings in the Layer Style dialog box as shown here, and then click OK. Make the configurations as shown and set the Blend Mode to 'Dissolve' to create rough color on the inside of the text.

## STEP 26. Adjusting the Title Transparency

With the action layer still selected, use the Opacity slider on the Layers palette to set the layer's Opacity value to 75%.

### STEP 27. Adding Vertical Lines

Click the Create a new layer button (Shift+Ctrl/Command+N) in the Layers palette to add a new layer called Layer 2. Double-click the Layer 2 layer name, type "Line_03," and press Enter. Choose the Brush tool from the toolbox. Click the Click to open the Brush Preset picker button on the Options bar, and double-click the Hard Round 1 pixel brush in the palette. Set the foreground color to white, if needed. Press the Shift key when dragging to draw vertical lines on the new layer, as shown here.

### STEP 28. Completing the Line_03 Layer

With the Line_03 layer selected in the Layers palette, use the Opacity slider to change the layer's Opacity value to 77%.

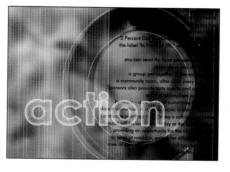

### STEP 29. Naturally Blending the Vertical Line Image

To make the lines appear more natural, drag the Line_03 layer below the shell layer in the Layers palette. This creates a very rhythmic image.

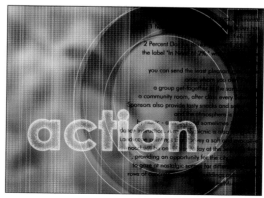